TROUBLE IN
PARADISE

TROUBLE IN PARADISE

KUNST
HAL
ROTTERDAM

nai010 publishers

It is an honour and pleasure to present the 'Trouble in Paradise' exhibition and its catalogue. This publication shows part of Rattan Chadha's collection, built up over the past 20 years, during which he was advised by curator Liesbeth Willems. It is always special to work with a private collector on a publication and exhibition about a collection that is initially so personal and is subsequently made accessible to a wide public. It is a continuous process of making choices, discussing, juggling the pieces to find the right fit: can a chronological line be discovered in the collection, or perhaps a theme, and what is the story the collector would like to tell? How should the works be presented? All kinds of questions you have to answer together in order to achieve the optimal result.

The Kunsthal Rotterdam is a dynamic institution that has been staging interesting, special and spectacular exhibitions for over 25 years. Not having its own collection means an immense amount of freedom in programming. That is also evident from the diverse and contrasting selections, where various disciplines are visited: photography, visual art, history, ethnography, fashion, architecture and design. Because of this freedom, working with individuals and their special collections has become an integral part of our programme. It also means that entire or part collections do not have to be related to the museum's own collection, which makes it possible to highlight the identity, emotion and choice of the collector. Important exhibitions of private collections were 'Meesterlijk Verzameld: Gustav Rau Collection' (2001), 'I promise to Love you. Caldic Collection' (2011), 'Avant-gardes. The Collection of the Triton Foundation' (2012), 'The Museum of Everything' (2016) and 'Human/Digital: a Symbiotic Love Affair, digital art from the Hugo Brown family collection' (2017). The exhibition 'Trouble in Paradise' fits seamlessly into this list and adds a new chapter with its uniqueness.

The exhibition and catalogue are divided into three themes with the titles 'Soul Searching', 'Delicious Confusion' and 'Forever Young'. These titles were chosen in consultation with the collector and curator and refer to the various phases of the collection: Chadha focused initially on the human figure, he then shifted his attention to works that are sometimes figurative, at other times abstract, but are all primarily discomfiting and questioning, while in recent years the collection has moved towards a phase in which materiality and texture appear to be of particular importance.

In the article by author and critic Sacha Bronwasser, based on an interview with Rattan Chadha, she

FOREWORD

describes his burgeoning love for art, the start of the collection, the important role played by Liesbeth Willems and his urge for new ideas, for change and progress. Just reading the article gives me energy and makes me curious about the works he has selected to be shown. A tour through Rattan Chadha's collection, on location or by turning these pages, is inspiring because it disturbs now and again, surprises with its combination of known and unknown artists and because it is a daring collection that does not immediately reveal itself to the viewer, but challenges us. And that's just what we love, at the Kunsthal. Jhim Lamoree takes us through the history of collecting art in the Netherlands. While doing so, he focuses on the best-known historical patrons/collectors who founded a museum, such as Helene Kröller-Müller and Pieter Teyler, and more recent examples such as De Pont in Tilburg. Lamoree places Rattan Chadha's collection in the Dutch context and discusses numerous acquisitions that are in no way similar, except for the fact – and I quote – 'that it is art with a frayed edge'.

With thanks
First of all, our heartfelt thanks go to Rattan Chadha for the courage to share his choice of art with us and make it accessible to everyone. I would particularly like to sincerely thank Liesbeth Willems, the Art Curator of the KRC Collection, for her contribution to the collaboration on both this catalogue and the 'Trouble in Paradise' exhibition. Contrary to what the title of the exhibition suggests, she turned the whole process into a joyful occasion. Also on behalf of Liesbeth Willems and Rattan Chadha, I thank both authors: Sacha Bronwasser and Jhim Lamoree for their interview and article, respectively; architects Rob Wagemans and Sebastiaan Kaal from bureau Concrete Amsterdam for the exhibition architecture; designer Roosje Klap for the magnificent design of the book and exhibition; nai010 publishers, especially Eelco van Welie, for this beautiful publication; curator Eva van Diggelen for the concept phase and Charlotte Martens, Kunsthal curator, for her energetic and decisive project management.

I wish you a great deal of reading pleasure with this compilation from the inspiring Rattan Chadha collection.

Emily Ansenk
Director Kunsthal Rotterdam

GOING OUR

OWN WAY

Seeing an artwork for the first time and then not being able to get it out of your head. It's intuition, a feeling that you develop after years of looking. Looking is a creative process in itself.

This is the basis for my advice: I want to convey the feeling I have with an artwork to the collector. It is also important that you learn to sense what makes an impression on the collector. After 18 years, this interaction has led to an idiosyncratic collection where three characteristics have developed: *Visible - Communicative - Going our own way*. The latter characteristic perhaps shows something of both our personalities.

Besides internationally renowned artists, the work of promising young artists occupies a central place in the KRC Collection. For Rattan Chadha, the pleasure of being surrounded by art goes hand in hand with getting to know the ideas and emotions of young people. They show us who we are and what we stand for. Art can show changes in society and help us to think differently, more conceptually.

The collection is inspired by man and the human condition, and is expressed in a wide variety of materials and techniques, which include chewing gum, plastic and aluminium, carbon and LED light.

But also artists who use the new media to spread their images.

Liesbeth Willems
Art Curator KRC Collection

ART GIVES COURAGE

by Sacha Bronwasser

How did born entrepreneur Rattan Chadha start collecting art and what does he look for in an artwork?

A conversation with Rattan Chadha and KRC Collection curator Liesbeth Willems

When I arrive at Rattan Chadha's company in Voorschoten, there is something that makes me laugh. First you see behind a large white fence the imposing broad, white façade of De Zilverfabriek, the former building of gold and silver producer 'Koninklijke Kempen & Begeer'. Since 1985, the completely renovated building behind the façade has served as the offices for entrepreneur Rattan Chadha's companies: first for Mexx, and now for the CitizenM hotel chain. Part of his art collection, the KRC Collection, is also on display there. I drive my car through the original art nouveau gate, behind which the gravel on the wide driveway crunches just as it should. Everything is stately and in perfect condition, a welcome that will please any business associate.

And then a surprise awaits you at the front door: a green steel dustbin, like the ones you find everywhere in the Netherlands in public spaces, containing a twisted bicycle wreck. It's an artwork by Dutch artist Marc Bijl: *Composition with Bicycle and Dustbin* (2000). It is inevitable that every visitor's eyebrows move, up or down, at the sight of this work that seems so completely out of place. Teleported from a fairly rough street in a big city to this chic location, to welcome everyone. Welcome to the domain of a businessman and collector who does everything just that little bit differently.

I am here to speak to Rattan Chadha and also to the curator who has been shaping his art collection for 18 years: Liesbeth Willems. The collection, which originated in the 1980s but which reached serious maturity from 2000 onwards, is quite outspoken and pretty unpredictable. There's sex, drugs & rock 'n' roll, but also deep melancholy and abstraction. Artworks that can rarely be captured at a single glance, and require a second look and interest in the artist's intention. Art by big, famous names but also by beginning artists. Work by artists who then took a completely different path, or work by very elderly artists who are an example to young people. 'It is always the work in the first place that intrigues me. I buy a work, not a name', says Rattan Chadha about this approach. What unites the collection is a high degree of rebellion and curiosity about unexpected angles.

In one of Chadha's four houses, where he lives with his partner Catia von Hütz, I also observe how the art fits into the domestic environment. In the winter, the family usually lives in the Kensington district of London in a spacious apartment built in a former Edwardian school. Art is prominent everywhere; for example, one wall of the living room is entirely taken up by the apocalyptic fantasy landscape *The Brethren of the Stone: Vista ex machina* (2006) by Jen Liu (1976), and dinner is served between two completely different photographs: a classic portrait of Desirée Dolron (1963) and an enigmatic collage by Alexandra Leykauf (1976).

Because of the lounge with bar on the ground floor, the house is also suitable for receptions. Here too, the entrance is intended to provoke. Upon entering you immediately see the large photo work *Shit on Us* (1997) by Gilbert & George. A little further on there are two pictures of Lady Di: on one she sucks suggestively on a biscuit and on the other she raises her middle finger. Something is not right in this image; the woman is a lookalike, the work is by conceptual photographer Alison Jackson (1970). And at the back of the room there is a green canvas with the text 'I can't give you anything' on it, a 2005 work by Adam McEwen (1965). Even just the combination and meaning of these three artworks, so demonstratively presented in the hall of a wealthy businessman, could keep you speculating for a long time.

I am curious about the motives of someone who is very successful in business, but who does not collect art as confirmation of that success. That is why I am speaking to Rattan Chadha in the Netherlands. He receives me in the late summer of 2018 in his office in Voorschoten. A fit man in his sixties in a casual turtleneck under a dark blue suit. He starts the conversation even before we sit down, reacts immediately, doesn't waste any time on asides and bursts out laughing at regular intervals.

His statements are short and to the point, and if he doesn't know what to say for a moment, he asks a disarming question: what do you think?

When asked why he especially likes very contemporary art, he simply says: 'Because I don't like the old. We know that. The old, that's already been done.' His curator, Liesbeth Willems, speaks up when it comes specifically to the collection, and the role she plays as curator. Rattan Chadha bought works of art sporadically from the mid-1980s, but it became a serious collection from the moment Liesbeth was involved. Chadha and Willems have been working together for almost two decades and need just a few words to understand each other.

SACHA BRONWASSER (SB): We see three themes in the exhibition: 'Soul Searching', 'Delicious Confusion' and 'Forever Young'. These correspond to three lines in your collection. Is that the result of a plan?

RATTAN CHADHA (RC): No. Art is something that grows with you. You could say that art in general documents history, but with a collection you are also documenting your own history. How you grow, how your taste develops, and how you see and understand more and more.

SB: So if we look at these themes...

RC: ... you can see that, yes. When I was younger, I worked seven days a week and was always travelling. I think I experienced a certain emotional emptiness and when I recognized it in a work, it appealed to me. That's why I bought that portrait by Marlene Dumas, *Sad Romy* (2008), for example. The actress had all the fame, but she also looks so unhappy. So human. Humanity, that's what I was looking for at the beginning of my collection.

SB: Another part of your collection is much more conceptual.

RC: I grew into that. I wanted to understand the idea behind artworks and was always interested in this aspect in my business operations as well. I encouraged the designers who worked at Mexx to go to museums, to look at art, to come up with concepts. So not this: we see a nice blouse and think of another variant for the following season, or the question of which colours to choose? But more: what is the story we would like to tell with this collection? I'm a concept guy, so that interested me in art as well. Something else I can draw from art is courage. Courage to develop something new, something nobody asked for, something that doesn't exist yet. I gradually became very interested in new materials and new media.

The first thing I bought in that area was by Kirsten Geissler (1949). When I first saw it, I was really blown away. I had never seen anything like it before: a projection of a virtually designed girl who reacted when you talked to her, laughed or frowned... at that time, in the late 1990s, there was no iPhone yet, there were hardly any computers, and this young artist made this work. Technology used for expression. Something completely different is the work by David Jablonowski (1982), the enormous carbon-fibre sculpture that stands in the entrance hall here (*Hardcopy [Tribal Spirit]*, 2016). Because of the properties of the material, he only had a minute or two each time to shape that huge thing. I find that inventive, it fascinates me.

SB: Was there art in your youth? Was it present in your parental home, did it play a role in your family?

RC: Not at all. Strangely enough, I only became interested in art after I had been in the Netherlands for a long time and was in business. And the road to art came through my first love, architecture – I studied that shortly before I went to a Business School in Delhi.

At one point in the 1980s things were going well in my business and I wanted to build a family home in India. I had already bought a piece of land and I had a house for the year 2000 in mind – I wanted to design the future of India. But I couldn't find a suitable architect; everyone wanted me to make a choice from model A, model B or model C.

I said: Come on, I'm trying to change the world here, not to have model A or model B or model C built! That's not interesting.

I had almost sold the land again when one day I was at an embassy and saw a sculpture. A granite statue. I stood as if incapable of moving and said: this is what I am looking for, for my house. It was... extremely contemporary. Perfectly finished, and very very Indian.

The artist, Satish Gujral (1925), said: I am not an architect and I cannot make sketches. But he accepted the commission. We then spent two days and nights together making shapes with plasticine and thinking and discussing what kind of house it should be, a house for the future and yet Indian. Architects then sketched it all out.

SB: So building a house brought you to art?

RC: Yes. His image gave me the courage. Instead of selling the land, I gained the insight in a flash that we really could find a solution for there. That is what I saw in that artwork. That's why, when I was travelling afterwards, I started going to museums and galleries to see more art.

SB: You had been buying art for some time before Liesbeth Willems became involved. How did the collaboration begin?

RC: I realized that I didn't know enough and that the art market was a crazy world – I needed someone. I was introduced to Liesbeth Willems through an interior architect. I liked the fact that she is an art historian, not a 'wheeler-dealer' – you see too much of that in this world. I was not interested in speculation, but in building up a collection.

I took it really seriously. My mother always said that thinking small and thinking big take the same amount of effort. So why not think big? I've always taken that idea along with me and the same goes for the art collection. I wanted to get it right.

SB: How did you know, Mrs. Willems, what would fit into the collection?

LIESBETH WILLEMS (LW): In the beginning I took a lot of books with me to gauge his interest...

RC (LAUGHING): To educate me...

LW: ... and our first visit together to Art Basel in 2001 was very significant. At that time it became very important as a trade fair. Rattan became completely captivated there by a work by Bill Viola (1951), the video five-part *Catherine's Room* (2001). A woman in a room represents the life of Saint Catherine in five stages.

RC: I was there for at least an hour!

LW: It was quite different from his previous work, so that was important. Another special moment has to do with the portrait of Angus Fairhurst painted by Elizabeth Peyton (1965). We wanted to buy something from Peyton, but the gallery, Sadie Coles HQ, didn't know us yet and it took a lot of effort to be taken seriously. I went back and forth, back and forth. In the end we were able to acquire that beautiful portrait.
Shortly afterwards Fairhurst took his own life. After that Rattan did not want to see the portrait anymore.

RC: I really love Elizabeth Peyton, and that work is so full of the sadness of life. But then... the painting became too precious to hang. That beautiful work always reminded me of his sad death.

LW: We had to give it back. It is through these kinds of events and travelling together that you come to understand each other. And Rattan is quickly enthusiastic, sometimes impulsive, and then I say: wait a moment. There is a better work by this artist. Or: don't we already have a lot of this kind of work in the collection?

SB: What really characterizes the collection?

LW: The engagement with the world, with how we live. Showing that there is more than the beautiful outside. Artists who tell a story and connect to the world, that's what we find interesting. Watch the video work by Cory Arcangel (1978): three young film stars – we no longer know who they are – whose reflection dissolves in the water... everything is so temporary.
Art is sometimes at odds with the environment Rattan Chadha usually finds himself in – his friends and business associates don't have this on their walls. I find that special. At the opening of the KRC Collection in Voorschoten, for example, Marc Bijl's band Götterdämmerung played. That was a bit of a shock to some, but it gives Rattan a great deal of pleasure.

SB: You have been collecting since the 1980s. Your collection can be visited by appointment, you lend out work, and previously several works were performed on stage in a theatre performance (*The Great Art Show*, 2016). This is the first time that an overview is being shown in a museum and a large audience can see it. Why now?

RC: It has to do with the moment. I want to focus more on my art collection. Until now it was something that happened alongside my business and Liesbeth has told me more than once that we should go take it outside. My partner Catia, who has worked for Christies and has influenced my collection, has often urged this as well. But I kept saying no. Now the timing was good: it's time to share this. I had that desire before, a few years after I sold Mexx. I thought about a museum aimed at a young audience, I wanted to go all out for that. But then came the financial crisis, in 2008, and that hurt me badly. The CitizenM company had just started, I had one hotel, and I didn't really plan to expand to the 14 hotels in 8 cities worldwide that the company has now. But it was precisely during the crisis that I needed all my time and energy to build that company, just to let it survive. We succeeded and we work with local artists for those hotels, a new side of the company.
This exhibition is a renewed opportunity for me to focus on my art collection, to consider what to do with it now. Let's see if the reaction to this exhibition gives me new ideas for that.

SB: You often use the word 'new'. Do you get bored quickly?

RC: Yes. I'm not interested in the old. We need to move on. I have to move on, because (pretending he has a tape measure in his hands) my time is running out. I am very aware of that.

SB: And your response to this is not to take it easier...?

RC: No! It actually makes me hurry. Because stagnation is not possible. My conviction is: everything has to grow.

RATTAN CHADHA'S ART COLLECTION IN CONTEXT

by Jhim Lamoree

Collecting. It is a remarkable phenomenon that easily takes on pathological proportions. A need that slips into an obsession. You could also diagnose it as an instinct or a virus, because the condition has spread to every layer of the population. Depending on the thickness of the wallet, everything has already been collected at one time or another. From ceramics to buttons. The most prestigious area for the wealthy, because that's what I'm talking about, is art. For centuries. *Il faut bien passer le temps.* A striking example of Dutch origin is Helene Kröller-Müller (1869-1939). Unhindered by any kind of doubt and with pertinent preferences, she assembled a collection of more than 11,000 objects between 1907 and 1922. She purchased characteristic examples from every period of art history. A pottery horse from the Tang dynasty in China for example, but also a seductive portrait of a man painted by the sixteenth-century Venetian painter Tintoretto and the contemporary, almost abstract painting by Piet Mondrian, *Pier and Ocean* from 1915. She collected 'eternity', as the title of her biography indicates. And for eternity, I would like to add. She had a preference for art where the spiritual and the material coincide. In other words: if the aesthetic balance of an artwork veers towards all too realistic or all too abstract, it fell outside her artistic field of fire. Thanks to art educator H.P. Bremmer, whom

Kröller-Müller employed and who advised her for some time, Vincent van Gogh became the epicentre of her collection. From his oeuvre she collected a splendid overview, the most substantial collection of paintings and drawings by the artist that a private individual has ever purchased. The museum in Otterlo, which bears her name, owes much of its national and international fame to this collection. Helene Kröller-Müller's example shows that art collectors like you and me cannot escape the circumstances of their time. The taste for certain art changes over time. Kröller-Müller's esoteric ideas about art were no exception in her day. Her collection is as much a portrait of the prevailing views on art as of Helene herself. Despite being in thrall to time and circumstance, she has paradoxically achieved eternal fame with her collection. Which touches on a motive, conscious or unconscious, that cannot be underestimated. Few collectors are strangers to vanity. In collecting (or collection-forming, as it is also called) they find their life's work. Serious collecting does something to you; it possesses you and you enter the realm of fanatics. It becomes like breathing, it happens automatically, you can't avoid it any more. Once the virus has nestled, it is almost incurable. A chronic situation of being in the red in your bank account is one of the few remedies. No wonder the well-to-do do not know how to stop.

Textile Baron

One of these collectors is Rattan Chadha, born in India and raised in the Netherlands. The descendant of a family of steel producers in Delhi was born there in 1949. Since 1971 he has been living in the Netherlands where he has grown into a textile baron of stature, a born entrepreneur with an un-Dutch flair.

The import of clothing from India and the Far East was the beginning of a series of successful companies. In the early 1980s Chadha founded two clothing brands: Moustache for men and Emanuelle for women. In 1986, both brands merged to form Mexx: attractive and affordable fashion that is sold in stores of the same name, among other outlets. Mexx was a household name before chains like H&M, Zara and Uniqlo stormed the market. Mexx's different spelling with two x's as a sign of affection has become commonplace on the internet and social media.

Chadha is also at the forefront with his formula for Spaces: modern, well-equipped offices and communal workspaces that can be rented for a reasonable price and for a limited time. To work there, receive appointments, hold meetings or organize a presentation. The concept is a gap in the market for the growing army of freelancers, especially in the creative industry. CitizenM is Chadha's most recent business project. A hotel chain in the major cities of Europe and the US where the modern world traveller feels at home. With lounges full of designer furniture and no-nonsense restaurants.

By selling Mexx in 2001, Chadha became a wealthy man with time on his hands. So what now? Inaction was not an option. Anyone who knows Rattan Chadha knows that he has an insatiable curiosity. He is out to make discoveries, he launches ideas nobody else would have come up with. He is one of those people on whom little is wasted. He combines humour with self-mockery. He seeks adventure and at the same time calculates the associated risk. He is restless, emotional and intellectual, but not reckless. Reason does not lose its mind. His energy inspires enthusiasm and conversations with him about his collection of contemporary art give me a boost, at any rate. I notice that he appreciates an exchange of ideas. So beware, I'm biased.

After the sale of Mexx, Chadha started collecting seriously. He had the time and plunged into the adventure that is contemporary art, which he had come in contact with through his many business contacts and travels around the world. Those up until then sporadic encounters gave him a taste for more. Just like his companies, he set up the collection of art professionally. Art historian Liesbeth Willems, previously involved in the art collections of Frits Becht and Christiaan Braun, was appointed curator.

In the same way that Bremmer advised Helene Kröller-Müller, Willems is Rattan Chadha's advisor.

From the outset, she was made responsible for setting up and expanding the KRC Collection. The name of the collection is derived from the initials of the owner and consists now of more than 700 objects, mainly by international artists, which cover the entire artistic spectrum: drawings, paintings, videos, sculptures, installations and occasionally a photo as well. Since 2010, a selection from the collection has been on permanent display at the headquarters of KRC Capital, Chadha's holding company in Voorschoten, the former building of the silver brand Van Kempen and Begeer. Collectors, curators and museum directors from all over the world come to visit.

After her first introduction to Chadha, Liesbeth Willems organized an excursion to Art Basel, the annual fair for modern and contemporary art in the city of the same name in Switzerland – an indispensable event for collectors. The visit to Art Basel gave Willems an idea of Chadha's artistic affinities. Anything too impeccable, perfectionist or introspective is not his cup of tea. He prefers art that reflects on human deficiency and the state of society. Chadha became fascinated by contemporary art and invited Willems to formulate an approach for building his art collection.

Averse to Pigeonholes

Bam. The first purchase for the collection was ominous, much more than art for above the sofa: a portrait of a woman, painted in 1941 by Francis Picabia (1879-1953). Is the woman confused? Ecstatic? Panicking? Is she about to collapse? Whatever it is, something is going on! The painting is a striking, substantial acquisition for a beginning art collector.

Picabia is one of the forerunners of modern art, who, like his counterpart Picasso, changes styles like an actor changes roles. He is a prized painter's painter. Picabia questions the heroism of the modernist project in the arts. Since the breakthrough of postmodernism in the 1980s, he has been hailed as one of the heroes. 'Anything goes' became the motto. This first purchase was not only a declaration of principle for the collection that followed; it is also a portrait of its new owner, in whom a similar restlessness and ingenuity can be detected. Artist and owner are averse to pigeonholes. Now you will object that this observation can only be made retrospectively, but I dare to cast doubt on that idea: the choice of firstling inadvertently casts its shadow forwards. Art with a frayed edge. This is how I would like to characterize Chadha's collection. The choice falls on art that gets under your skin. Art that picks away at sacred cows, both artistic and social. 'Trouble in Paradise', the title of this selection from his collection in the Kunsthal Rotterdam, did not come out of the blue.

Take the installation by Candice Breitz (1972), from South Africa and working in Berlin. Her photos and

videos zoom in on the ubiquitous popular culture. *Queen (A Portrait of Madonna)* was recorded in Milan in 2005. The overwhelming video wall consists of 30 connected and stacked TVs with as many Madonna fans singing along with her album *Immaculate Conception*. The videos last almost 74 minutes. Some fans are more absorbed in the music and the lyrics than others. Most of them fall into a trance. The effect is as touching as it is contagious, if not sexy. Hips sway, shoulders shake, eyelids close, hands run through hair. Innocence and calculation compete for priority.

Candice Breitz's *Queen* refers to Andy Warhol's famous *Screen Tests* from the mid-1960s. Warhol observed with icy distance the young heroes of popular culture, including Bob Dylan and Dennis Hopper. Breitz is sympathetic to the Madonna fans who go crazy. In both cases you get the uncomfortable feeling that 'youth is wasted on the young'. If you look a little longer at Breitz's work, the 30 uniform square TVs look increasingly like a prison. Or take *PORN*, the sculpture by Marc Bijl (1970) from 2006. The sculpture throws the message in your face. The disproportionate size of the word overwhelms; the black letters leave drips on the white plinth. The atmosphere is ominous and oppressive, as aggressive as it is melancholic.

Which is caused by the references to the history of art and society. *LOVE*, the iconic image by Robert Indiana (1928-2018) from the 1960s, with the same typography and tilted O, serves as the model for *PORN*. Indiana celebrates free love, Bijl questions the vulgarization and pornofication of society. Most of the works in the KRC Collection are of the Breitz and Bijl calibre. Chadha opts for up-and-coming talent, for adventure and by extension also for risk. That is no easy task and curator Liesbeth Willems has to operate in an art market that is volatile and can get heated. An artist who is in great demand today can be forgotten tomorrow. The process of what we call the canon is in full swing in contemporary art. Which makes collecting so exciting: which art expressions determine the future? The KRC Collection is in good company; the admittedly much larger Sammlung Goetz in Munich and the Rubell Family Collection in Miami have a similar, forward-looking, adventurous orientation. In addition, the KRC Collection has a number of works of the Picabia calibre. Just as iconic for the collection as the examples mentioned above are the characteristic works of more established artists such as the Americans Richard Prince (1949) and George Condo (1957), the Swiss Thomas Hirschhorn (1957) and the English artist duo Gilbert & George (1943, 1942). Gilbert & George's controversial work *Shit on Us* hangs in the hall of one of Rattan Chadha's homes. That's what you call an entrance! *Sad Romy*, painted in 2008 by Marlene Dumas (1953) also fits in this category. The portrait of the

famous actress Romy Schneider shows that she could express the suffering of the world in her face. Whether it is true or excellently acted is irrelevant. Although Schneider's biography does play a role in the background, of course. After the death of her 14-year-old son, she started drinking excessively, which undoubtedly brought her own demise closer. She died at the age of 43 in Paris. Tragic – another term that adheres to many works of art in Chadha's collection. Which only increases its importance, because a life without tragedy is not a life. Mutatis mutandis this also applies to an art collection.

Patronage

Rattan Chadha is a recent link in a long chain of collectors. The family name of one of the best known in antiquity is immortalized in many modern languages: Gaius Maecenas (the Dutch word for patronage is *mecenaat*, for instance). The counsellor to Emperor Augustus gathered a pack of contemporary poets around him, whom he artistically inspired and financially supported. Horace and Virgil were his trophies. The name of the Roman contains an essential side aspect of the true collector: he is also a patron (*mecenas* in Dutch). A protector of the arts and by extension also a sponsor of the arts, as it's now called. Rattan Chadha, for example, supports a studio at the Rijksakademie in Amsterdam where an artist can further develop his talents for up to two years at Chadha's expense.

In the Netherlands, Pieter Teyler (1702-1778) stood at the cradle of the modern collector and modern patronage. While collectors nowadays are mainly from the department of excitement and entertainment, the Haarlem-born textile baron and banker Teyler is more in the care and society mould – he was also a child of his time. He collected drawings, graphics, books, coins and fossils to elevate himself and the rest of the population and he cared about the elderly, the poor and orphans. Thanks to his legacy of two million guilders, the Teyler Foundation, the Teylers Hofje and the Teylers Museum still exist in Haarlem. The latter institute was opened in 1778, making it the first public collection of art and science in the Netherlands.

Teyler's example echoes to this day. Names such as Van Abbe, Van Beuningen, Boijmans, Bredius, Kröller-Müller and Singer would undoubtedly have been forgotten if they had not been affiliated with museums that acquired their art collections free of charge or under more or less favourable conditions. Many prestigious museums that do not bear the names of their donors, such as the Rijksmuseum and the Stedelijk Museum in Amsterdam, were also able to flourish thanks to private art collectors. They stood at the cradle of the Netherlands as a museum country.

In recent decades, a wave of private collectors' museums has been added to the list. Of special interest to the KRC Collection is Museum De Pont in Tilburg, opened in 1992. Lawyer and car importer Jan de Pont determined in his will that a large part of his assets should be spent on 'the stimulation of contemporary art'. Hendrik Driessen, former deputy director of the Van Abbemuseum in Eindhoven, was appointed director of De Pont. His method of acquisition inspires Liesbeth Willems. After all, both have the ambition to acquire the most characteristic works in an artist's oeuvre, however difficult that may be, both to determine and to acquire.

What now?

Anyone who wants to be someone, wants to be different. But being different is not granted to many. Rattan Chadha falls into this outside category. He does not choose the extreme consequence; Chadha is not a revolutionary. His business activities saw away at the system of fashion, the rental of office space and the hotel industry – he does not overthrow the system. He changes it from within.
The contemporary artists Chadha chooses are similar sorts of highwaymen. That is how the boundaries are drawn. Just like Helene Kröller-Müller, Rattan Chadha cannot escape the ethical and aesthetic chains of the time. Free radicals like Marcel Duchamp (1887-1968) are in any case thin on the ground – I hardly see them at all in the present time. Well, all right then, Laurie Anderson (1947), Maurizio Cattelan (1960) and Tino Sehgal (1976) might possibly qualify for this special status.
So what now?! What is in the pipeline? At one time Rattan Chadha was looking for a space to present his collection, but not in the way a museum would.
'Art should not be buried,' he said on that occasion.
Is he still itching to examine and reinvent every aspect of the museum business? He has previously succeeded in other areas. I wager we'll be hearing more.

SOURCES

KRC Collection:
Silvia von Benningsen, Irene Gludowacz, Suzanne van Hagen, *Global Art*, Hatje Cantz Verlag 2009, pp. 102-109.
Friedrich Bonzen, Max Hollein and Olaf Salié (editors), *Global Corporate Collections*, Deutsche Standards 2015, pp. 291-297.
Liesbeth Willems, *KRC Collection*, First and Second Edition, Voorschoten 2011 and 2014.

Marc Bijl:
Jhim Lamoree, 'Radical doubt', *Groninger Museum Magazine* 2/3 2012, pp. 52-57.

Candice Breitz:
Sarah Whitfield, 'Candice Breitz', *The Burlington Magazine*, November 2005.
Sarah Kent, Screen Idols, *Time Out London*, September 21-28 2005.

CONTEXT

Collecting:
Renée Steenbergen, *Iets wat zoveel kost, is alles waard. Verzamelaars van moderne kunst in Nederland*, Vassallucci 2002

De Pont Museum:
Jhim Lamoree, 'Pleisterplaats voor kunst', Museumtijdschrift nr. 6 Sep/Oct 2017.

Helene Kröller-Müller:
Eva Rovers, *De eeuwigheid verzameld. Helene Kröller-Müller 1869-1939*, Prometheus/Bert Bakker 2011.
Hildelies Balk, *De kunstpaus. H.P.Bremmer 1871-1956*. Thoth 2006.

'Know thyself' is an assignment that has occupied us since Socrates. By getting to know yourself, you also learn to understand the world and reality. This existential question is central to this chapter of Rattan Chadha's collection of contemporary art. The works gauge the soul of man and that of society.

Portrait of a woman, painted in 1941 by Francis Picabia (1879-1953), was Rattan Chadha's first substantial acquisition for his art collection. The unknown woman is in a confused state. With her watery eyes, half-open mouth and head pointing helplessly to heaven, is she about to become unwell? Is she in ecstasy? Her panic represents the panic many of us experience. She is a wandering soul. She is struggling with the question 'who am I?' – just like us. The painting is a declaration of intent for the collection as a whole and this chapter in particular. It raises the question of the human condition. The moving, intensely sad portrait of Romy Schneider fits in with this. The painter Marlene Dumas (1953) has caught the famous actress in a distraught state. She is more specific than Picabia by reminding us that everything has a price – fame and success do not always guarantee happiness.

The video wall by Candice Breitz (1972) points to yet another loop in the Gordian knot in which our soul

SOUL
SEARCHING

can get entangled. *Queen (A Portrait of Madonna)* from 2005 addresses the influence of ubiquitous popular culture on the identity of many young people. Thirty Madonna fans sing along with her album *Immaculate Conception*. Some are more absorbed in the music and the text than others. Some lose themselves and fall into a trance. Others are aware of themselves. Innocence and calculation compete for priority.

Richard Prince (1949) zooms in on the heroism of the lonesome cowboy. Colour photographs of lonely, anti-social macho men on horses with lassos who are driving the cattle to grassy meadows or to their byre. The cigarette brand Marlboro used these and similar images for years to sell their product, especially to men. Smoking a Marlboro was tough. Dreams for sale. Prince removes the brand from the iconic photos and shows that they are clichés: as attractive as the greatest nonsense.
Just like Prince, Erik van Lieshout (1968) and Meschac Gaba (1961) show the mask behind which we like to hide. The flipside of the motto 'know thyself', you would think. Until you come across Oscar Wilde's profound statement: 'Give a man a mask and he will show you his true face.'
The five lanky street urchins in Van Lieshout's large drawing are toughness personified, or what would

pass for it. The boys come across as aggressive, but the exaggerated way they present themselves disproves that idea, it almost makes them endearing. Meschac Gaba has woven an enormous wig with artificial hair, inspired by dreadlocks.
The totem pole matches the specimens in Versailles during the *ancien régime*. If there's an ideal way to hide in something or pretend to be someone else, it has to be with a wig.

Knowing thyself is easier said than done, as many of the artworks in this chapter make clear.

20

Marlene Dumas
Sad Romy
(2008)

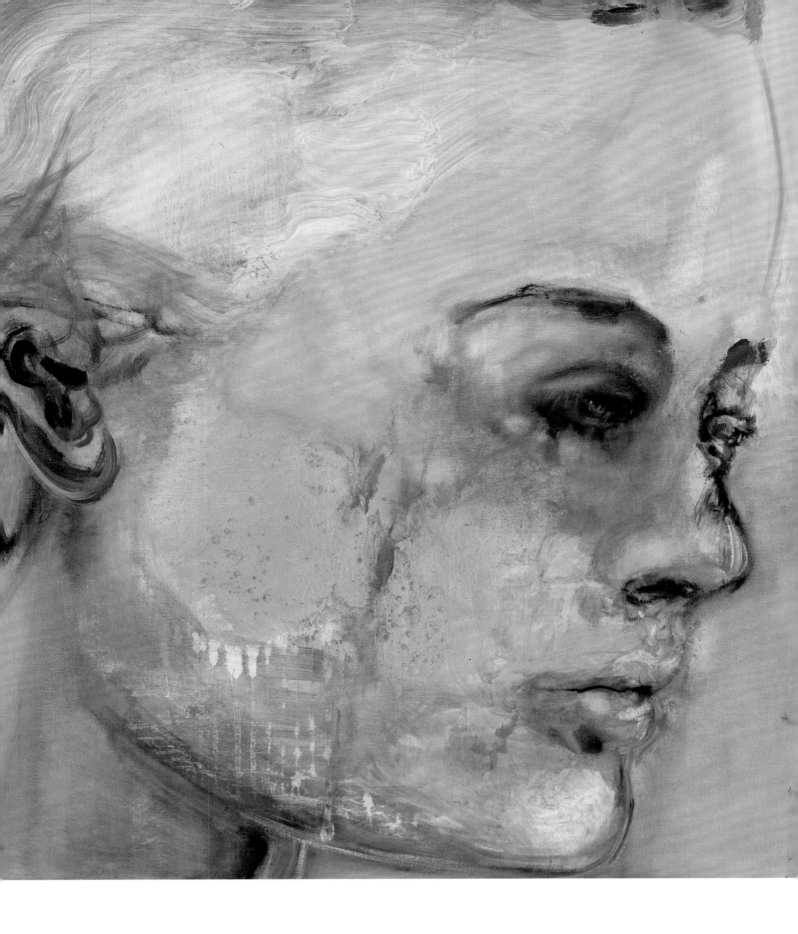

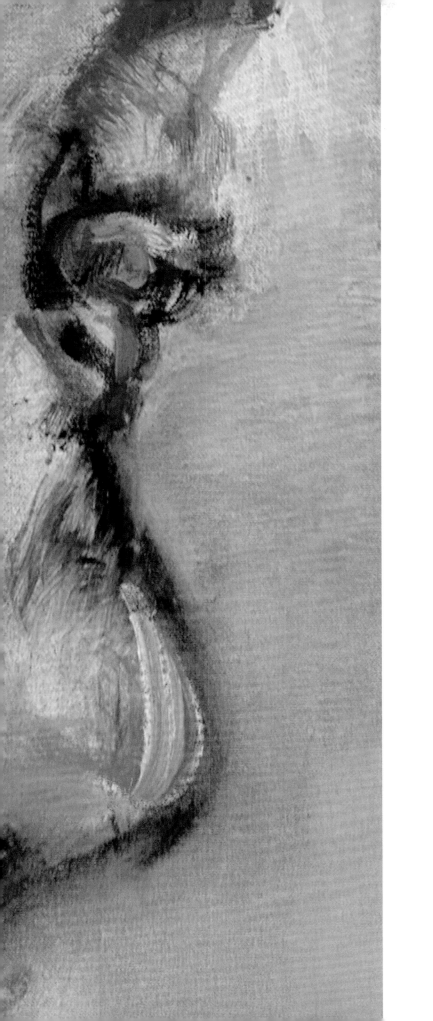

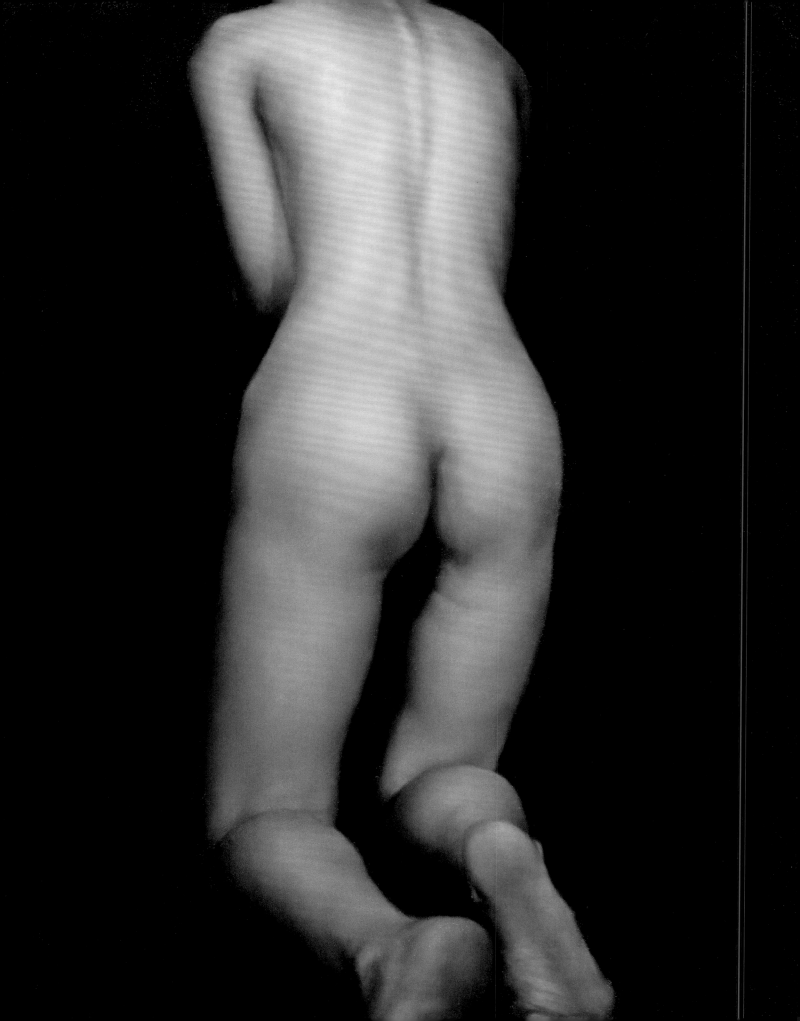

Naoto Kawahara
"Back"
(2010)

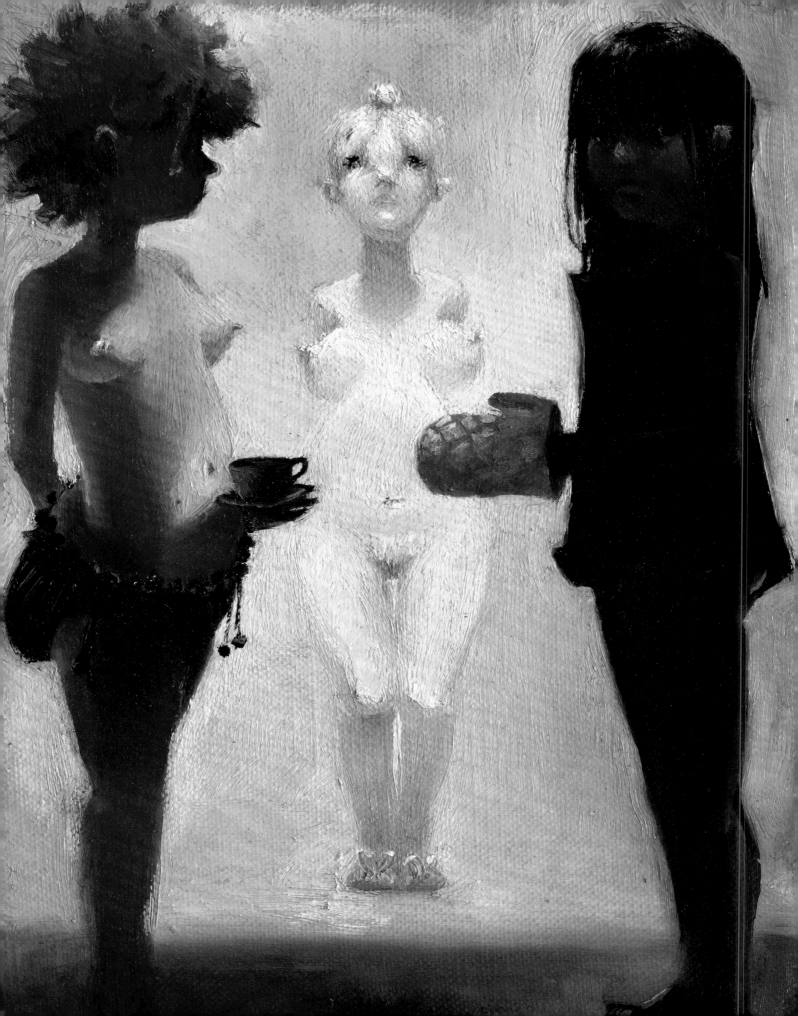

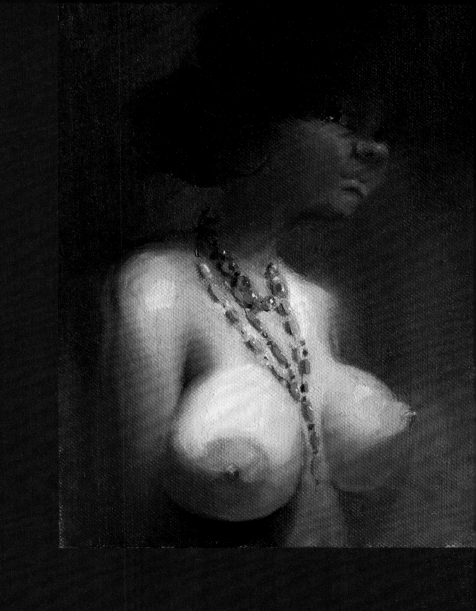

Lisa Yuskavage
Three Girls
(1996)

Lisa Yuskavage
Ethnic Nude
(2000)

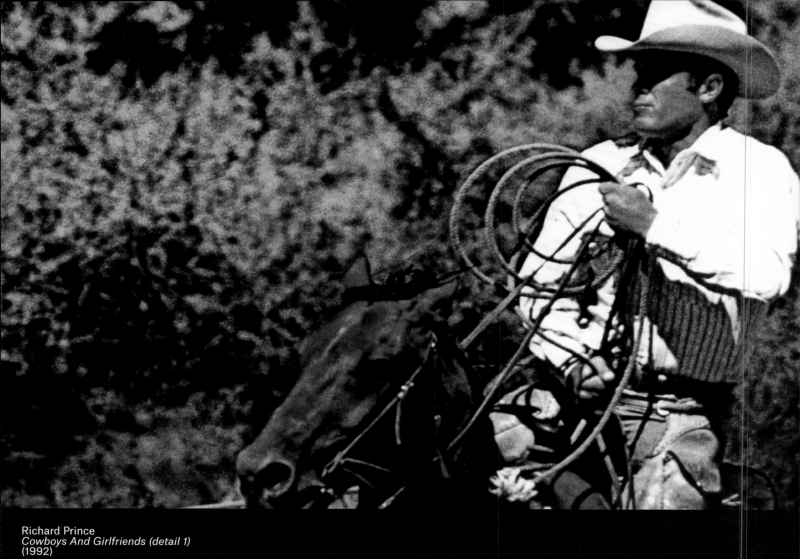

Richard Prince
Cowboys And Girlfriends (detail 1)
(1992)

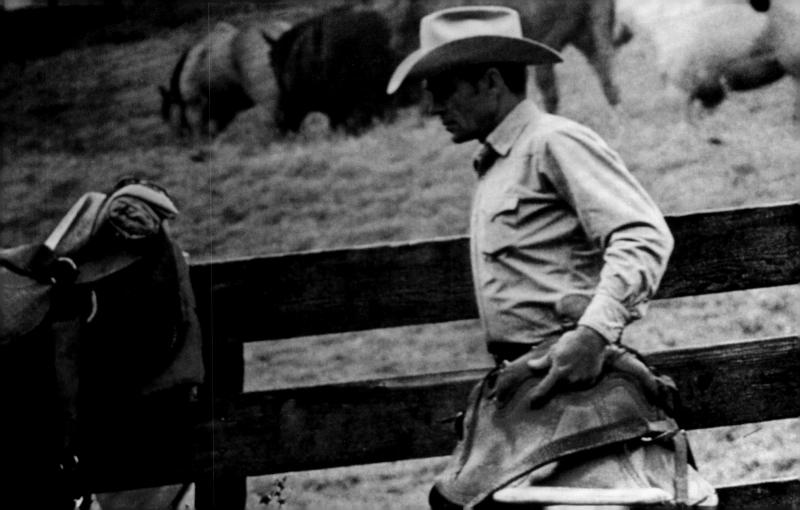

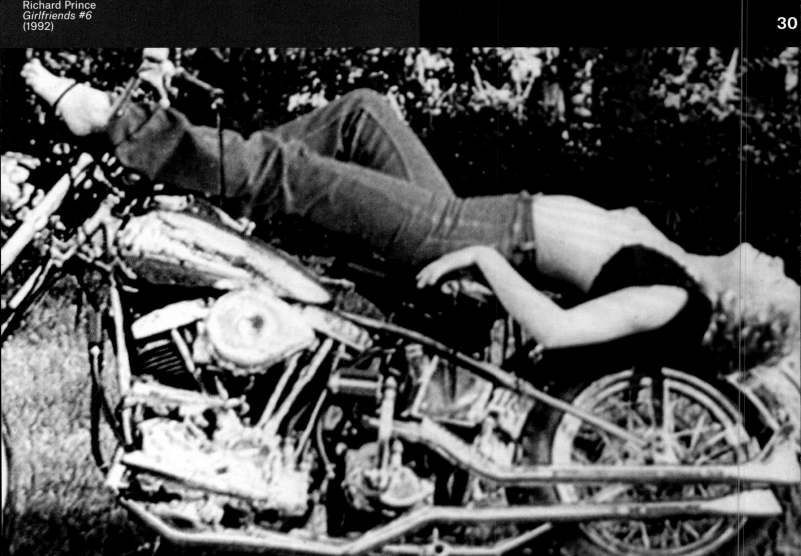

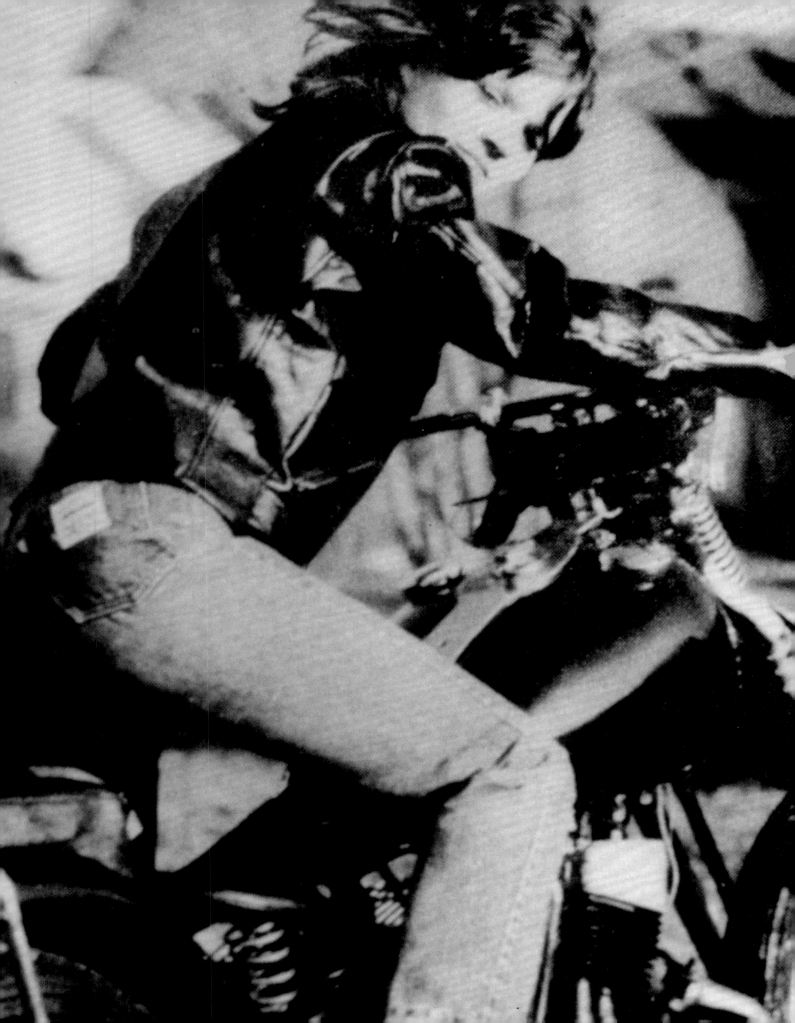

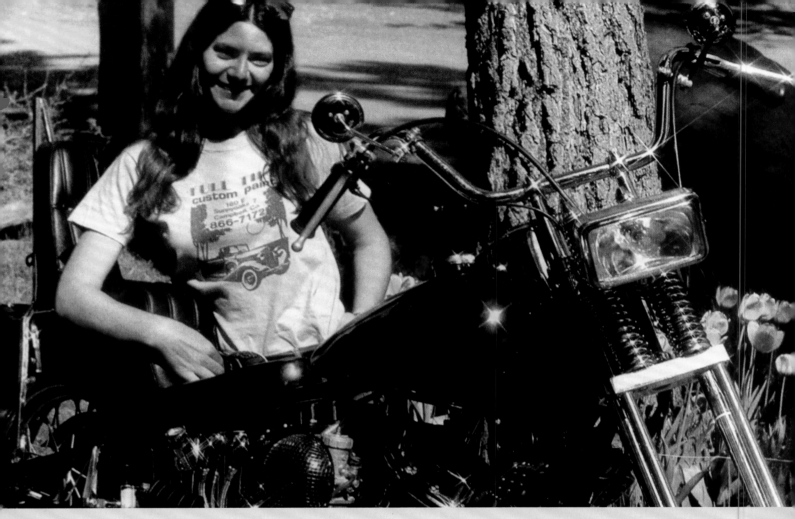

Richard Prince
Girlfriends #8
(1992)

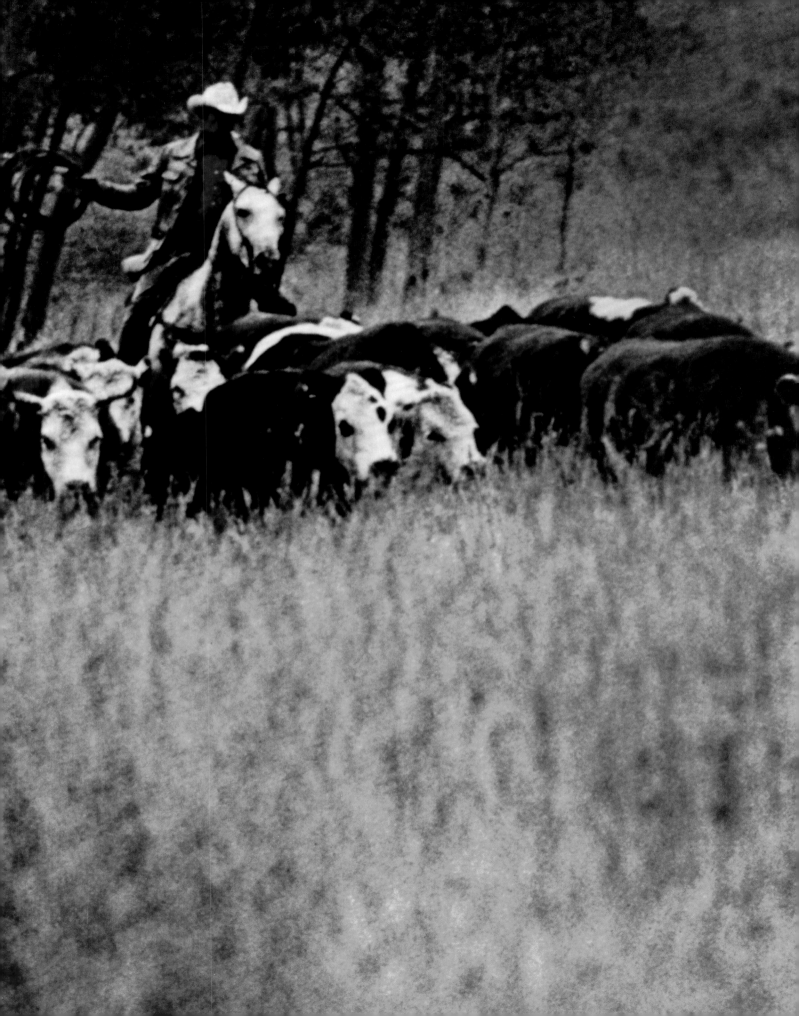

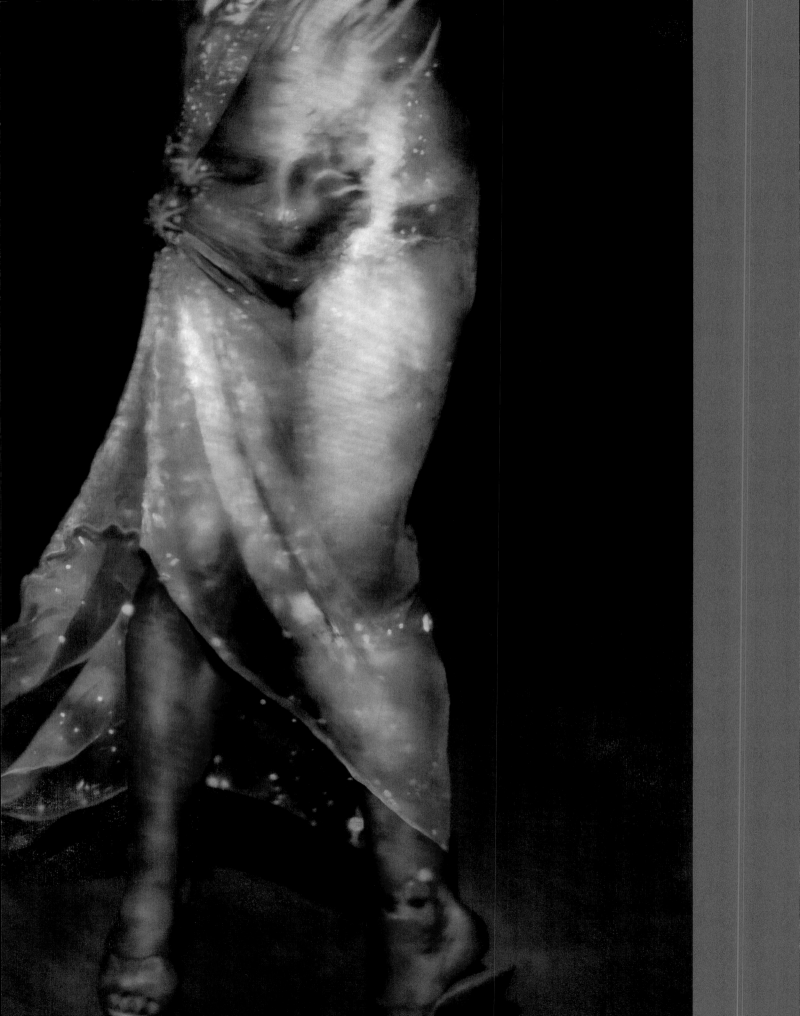

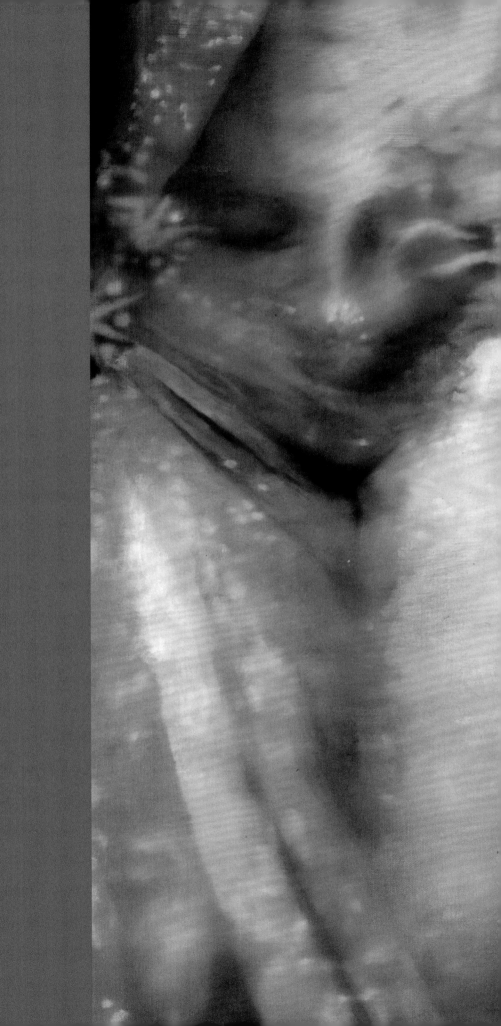

Johannes Kahrs
Figure Turning
(2006)

Mircea Suciu
"Me and the Devil" (color palette series 2)
(2017)

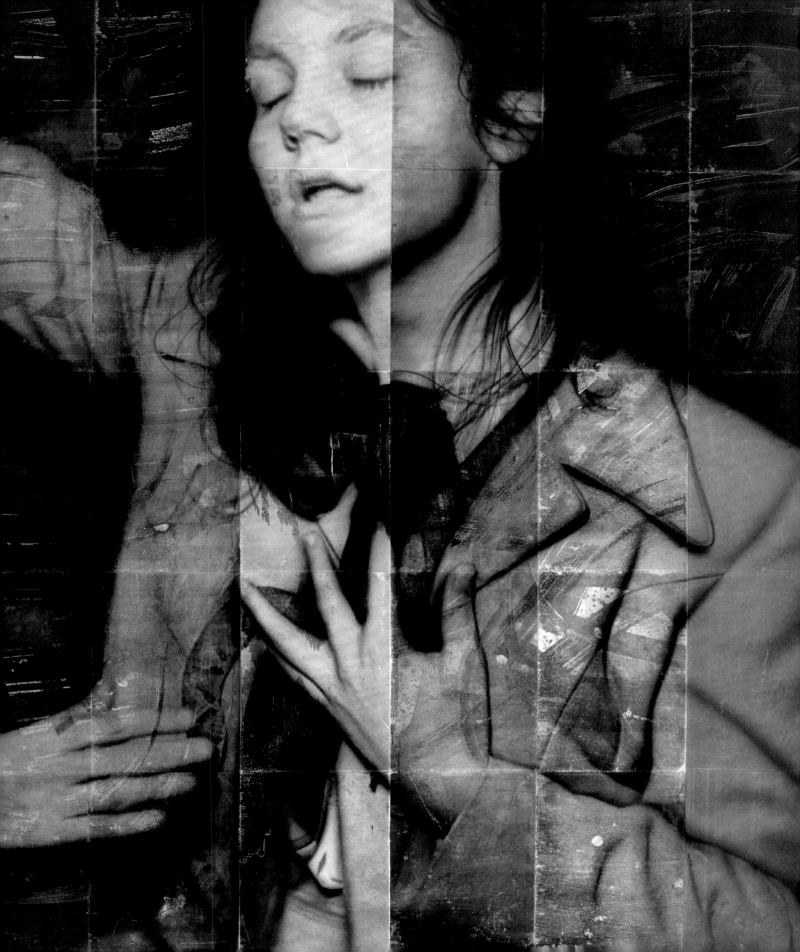

Michaël Borremans
Sweet Disposition
(2003)

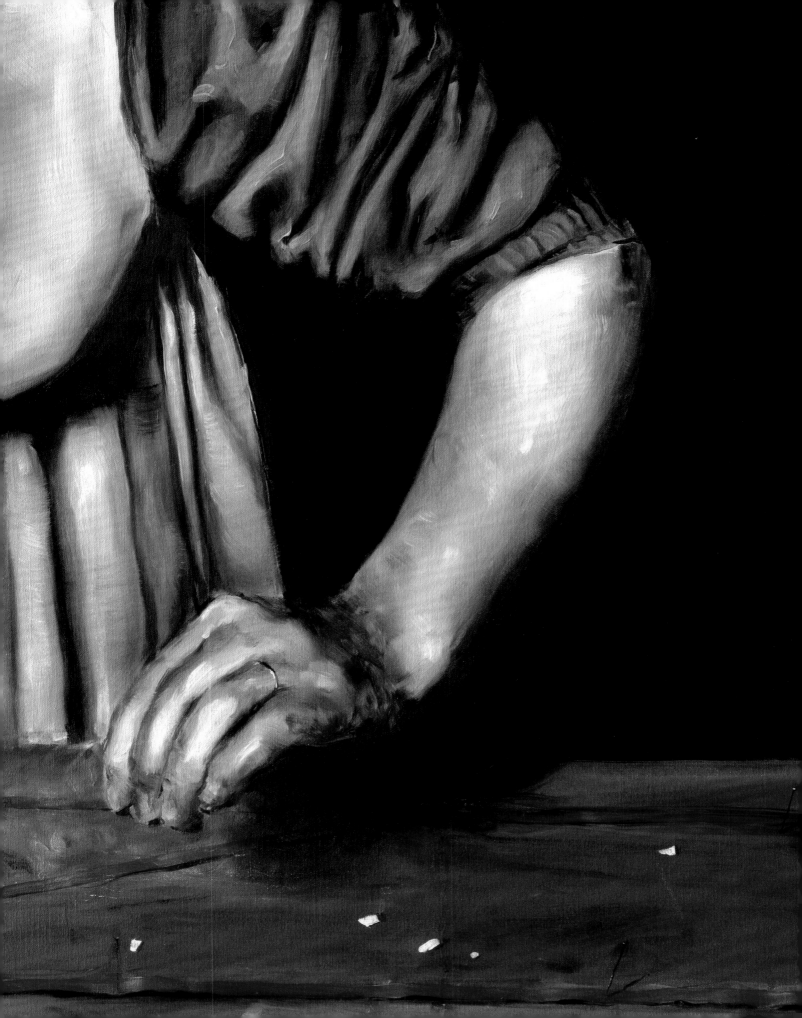

George Condo
Untitled
(2000)

Francis Picabia
Tête de Femme
(1941)

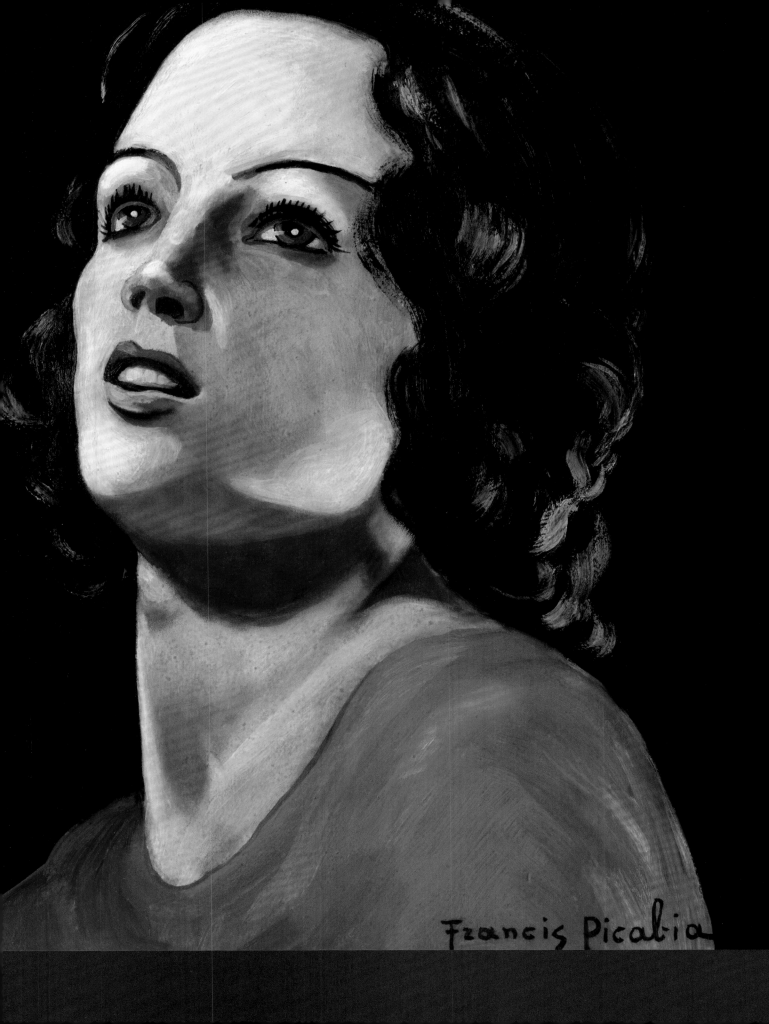

Francis Picabia

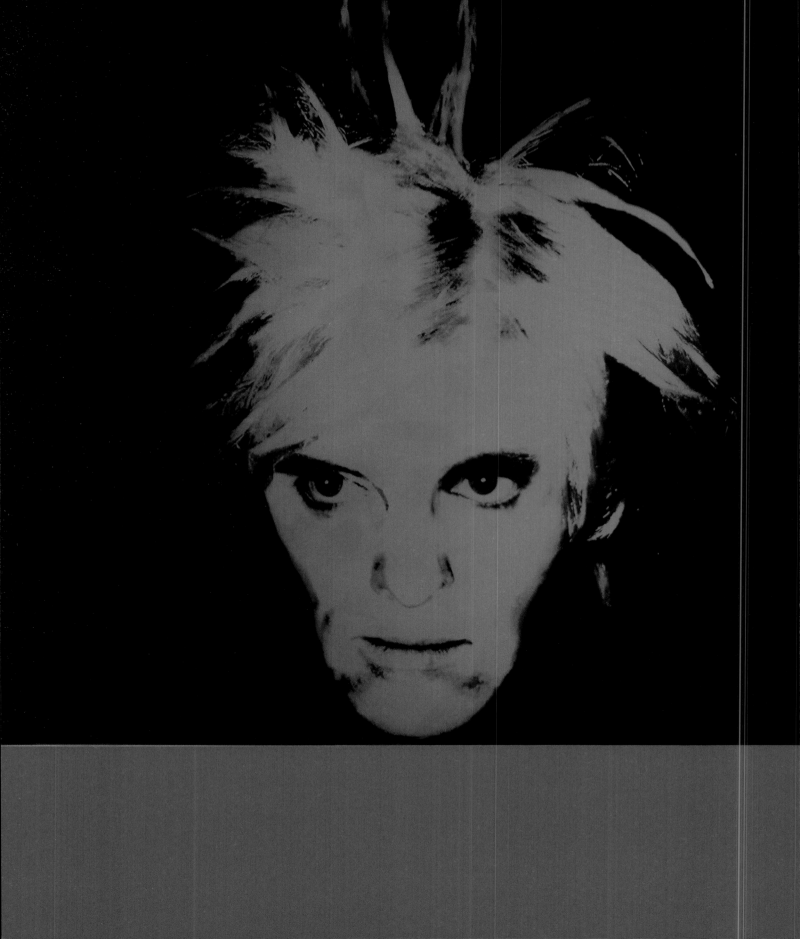

Gavin Turk
Large Red Fright Wig
(2011)

Rainer Fetting
Klabauter
(2015)

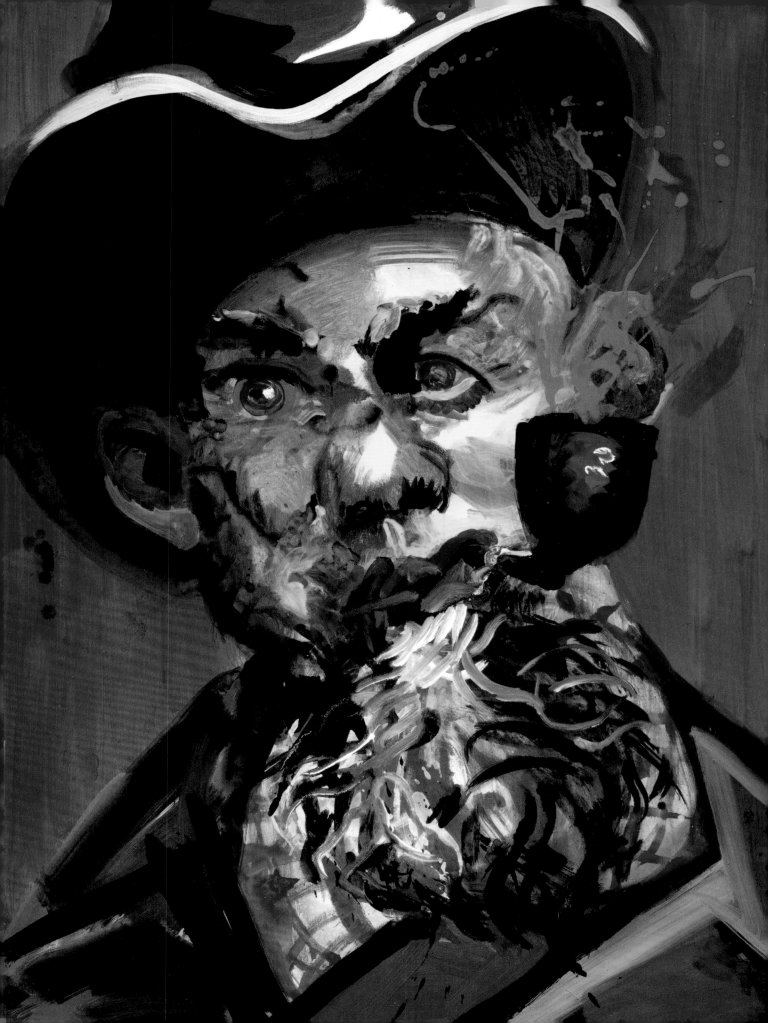

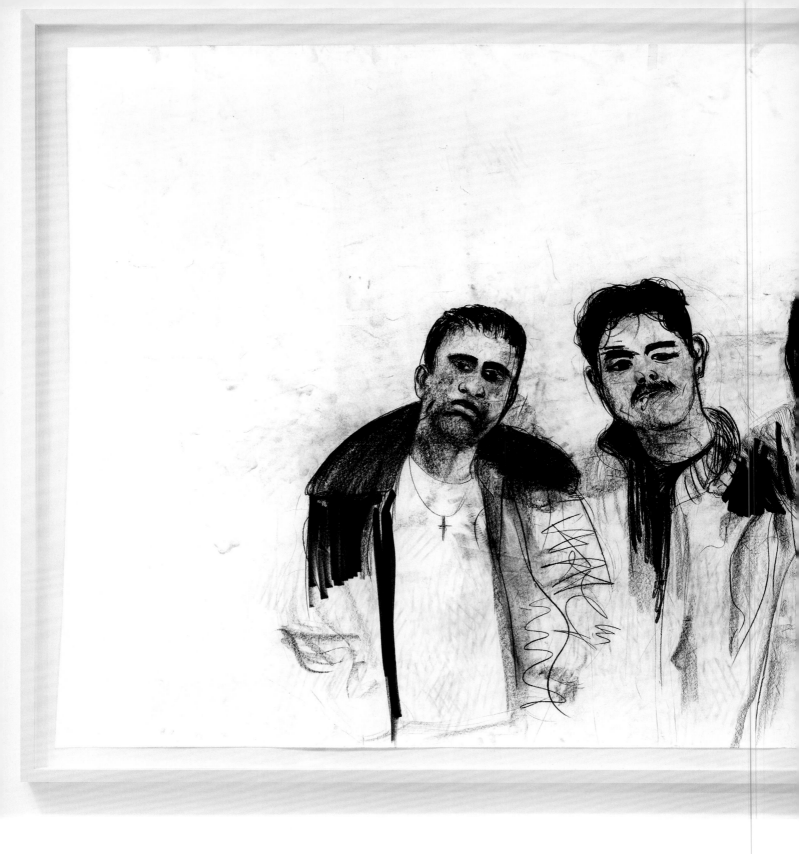

Erik van Lieshout
Five Boys - No Names
(2003)

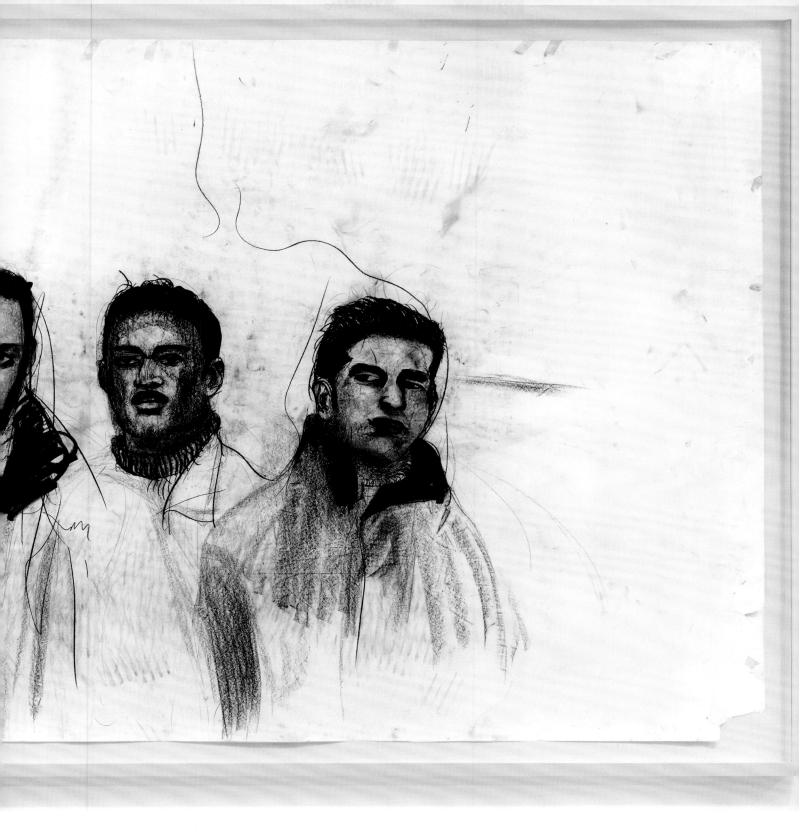

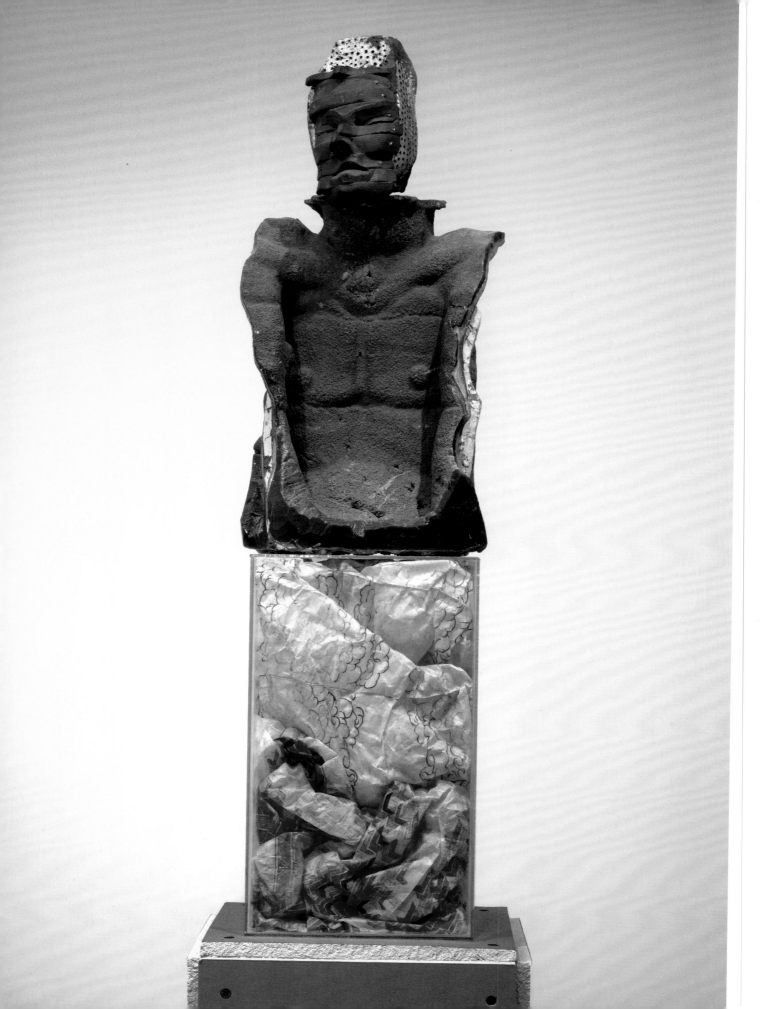

Matthew Monahan
The Sky is Fallen
(2005)

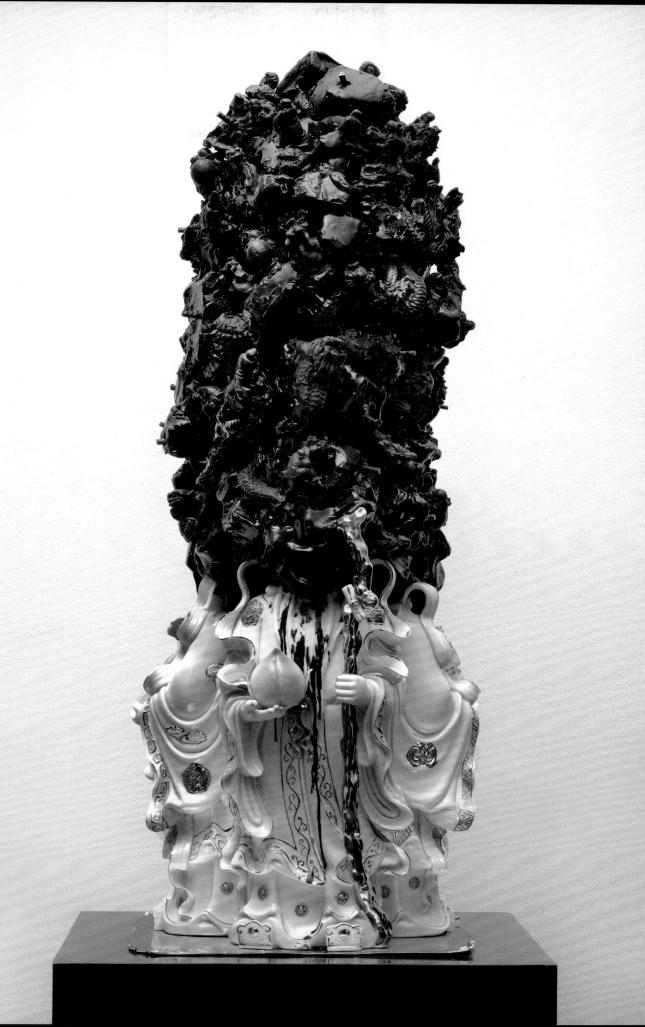

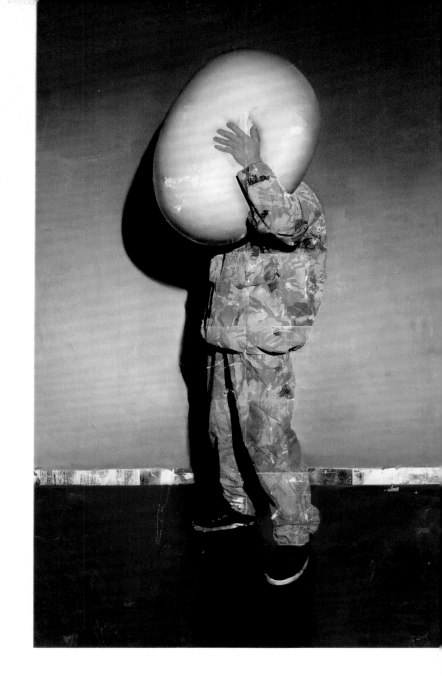

Mircea Suciu
"Nostalgia" (3)
(2014)

54

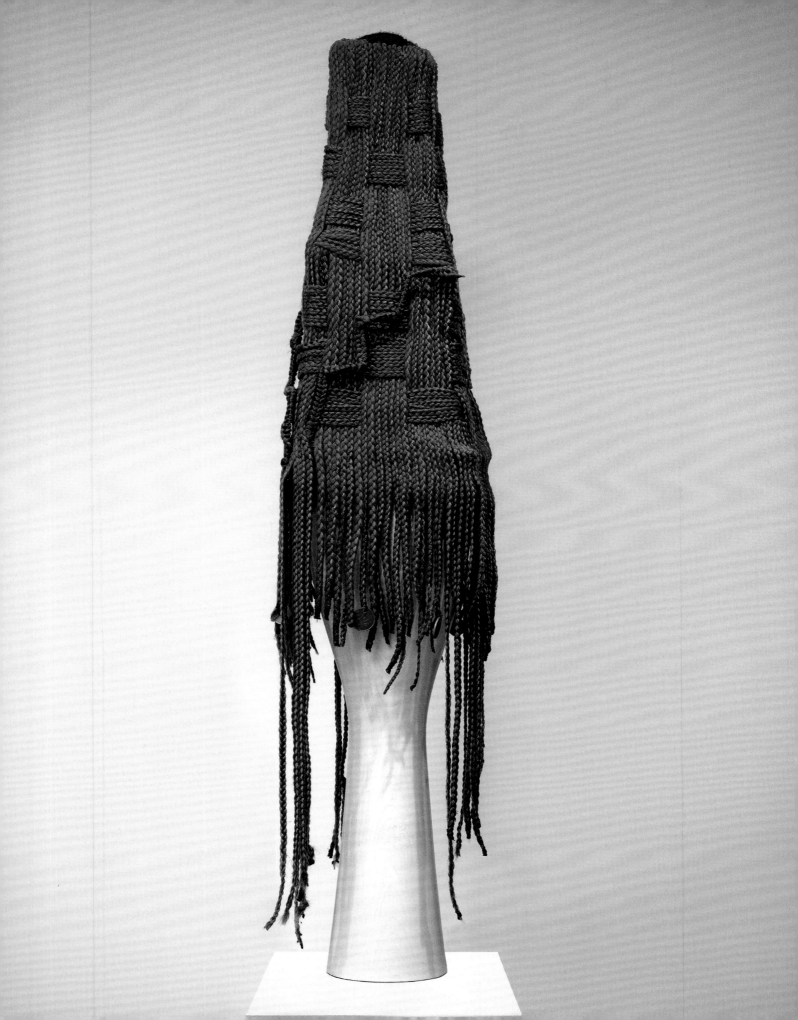

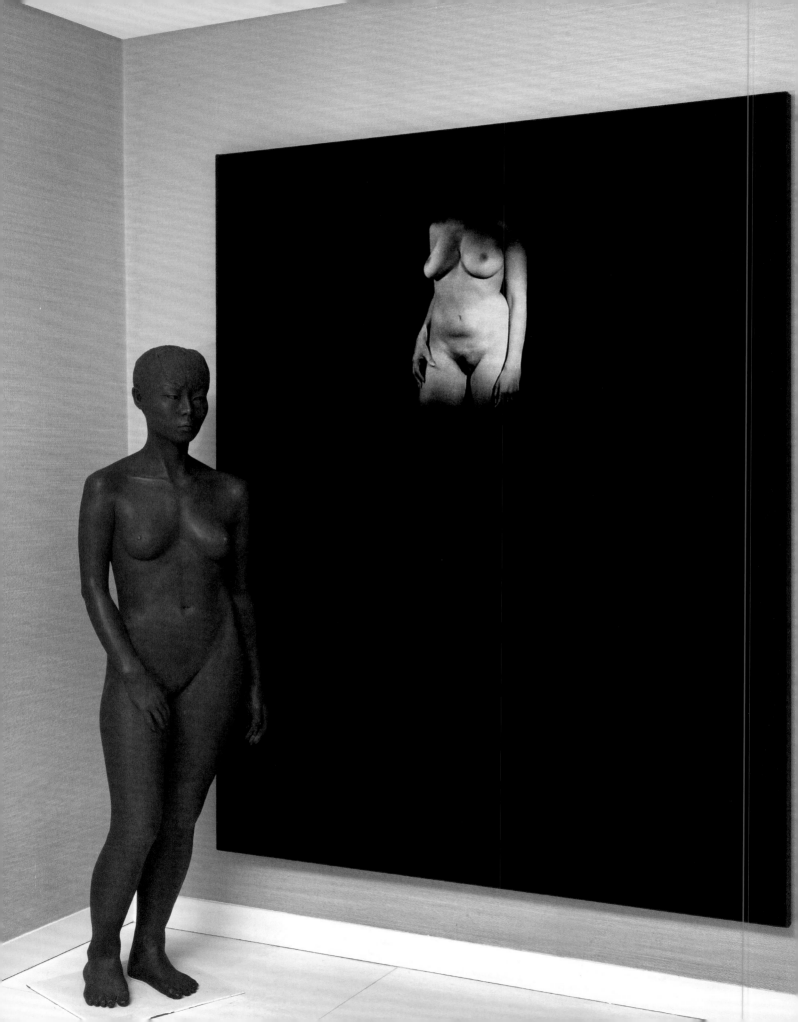

Barnaby Hosking
Untitled
(2004)

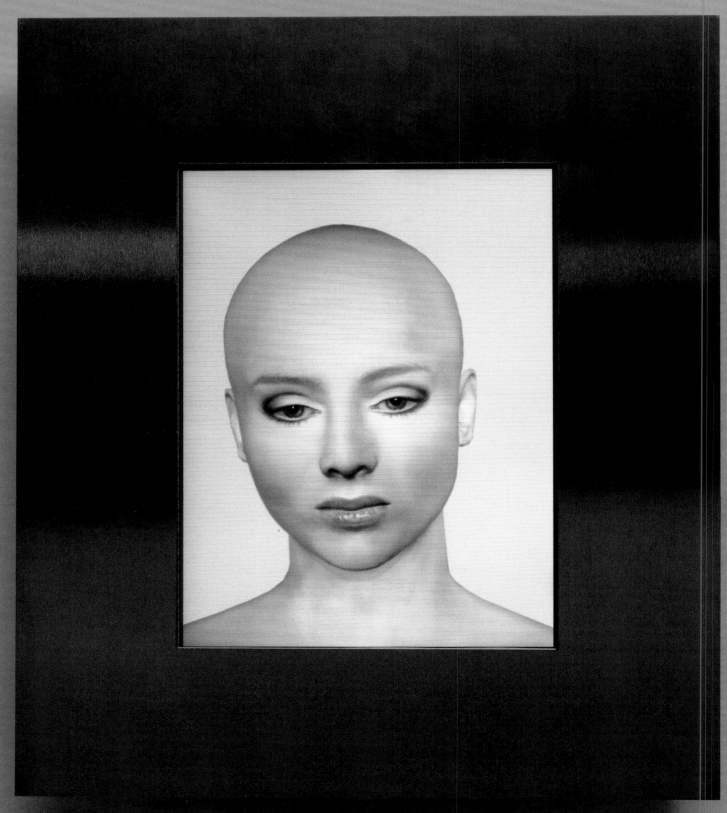

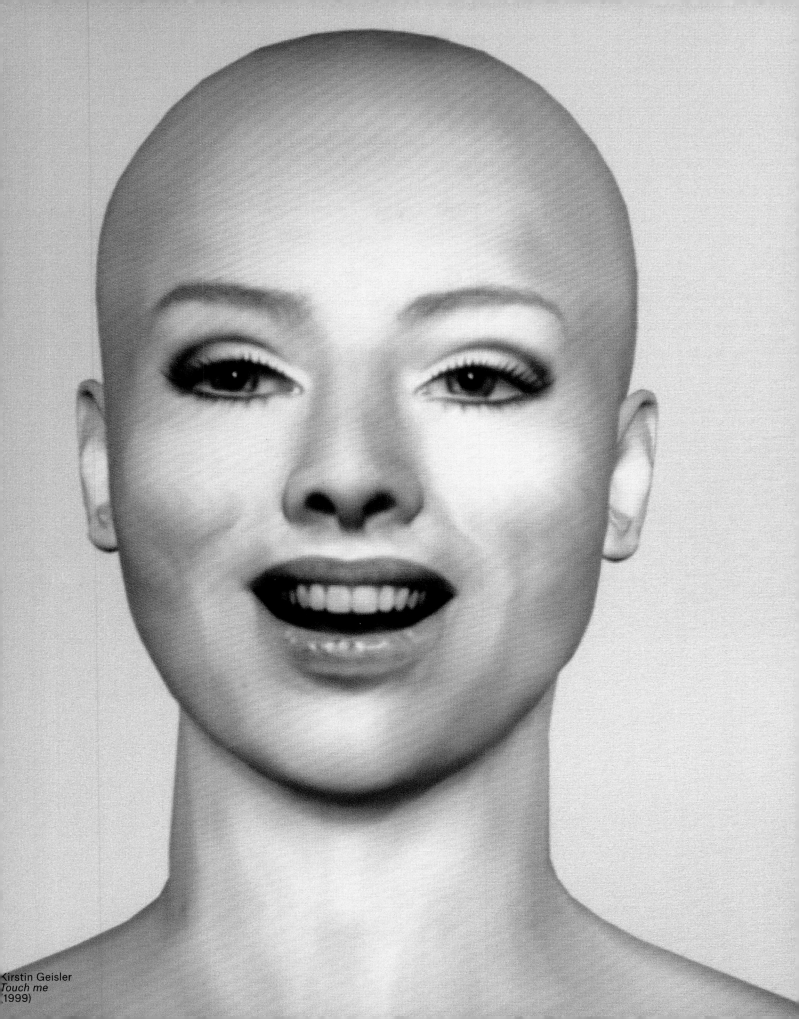

Kirstin Geisler
Touch me
(1999)

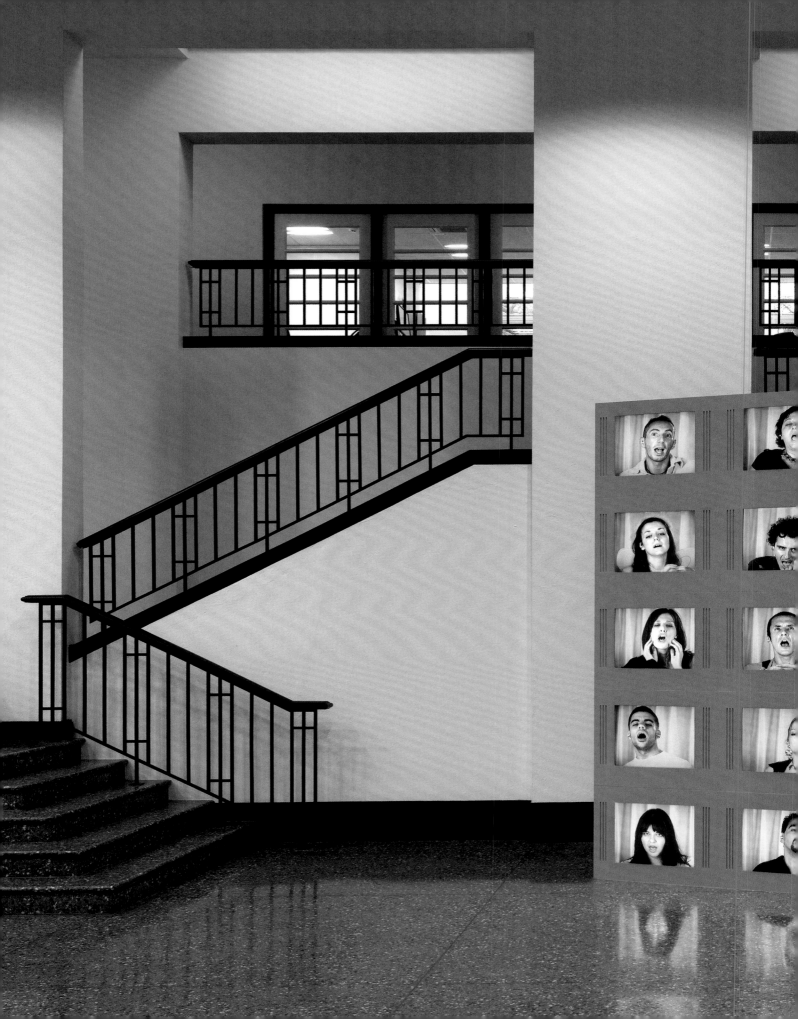

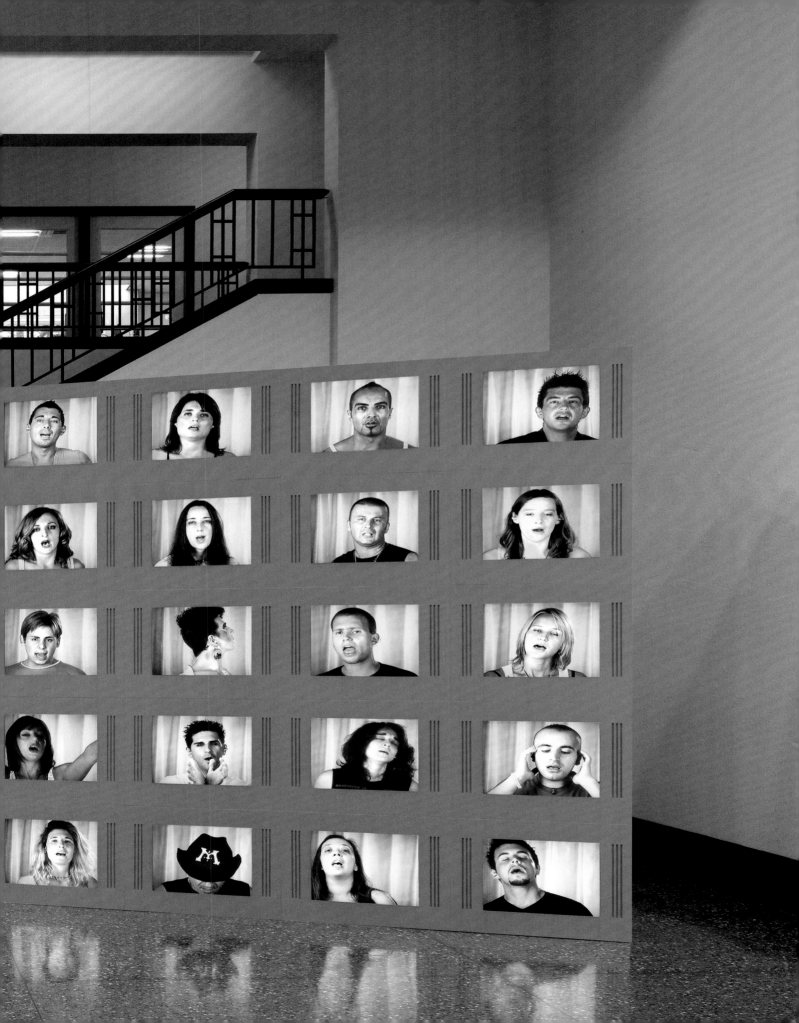

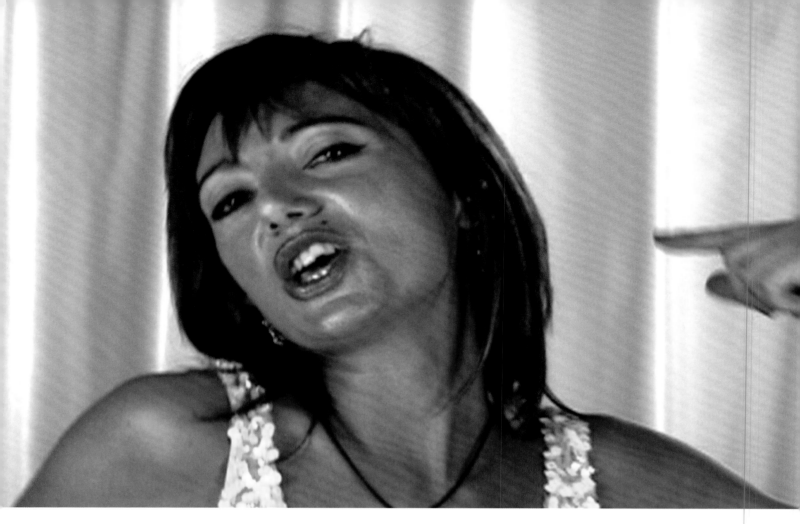

Candice Breitz
Queen (A Portrait of Madonna)
(2005)

DELICIOUS CONFUSION

Instinctively, the human race aspires to better or more and everyone wants to move onwards or upwards, which inevitably sometimes leads to delightfully confusing situations. Impulses often stand in the way of well-considered perspectives. The higher heroism that can derail is discussed in this chapter of Rattan Chadha's art collection.

The figures in Folkert de Jong's (1972) installation show ambition. In a grotesque way the king, emperor and admiral discuss how to conquer or divide up the world. Under a chandelier, on a raft floating on oil drums, with the gun and knife on the table. When grand plans are being forged with great drive, the nightmare is never far away. In the past and present. Folkert de Jong's work is a shout while Marcel van Eeden (1965) brings his insight to the fore in a whispered tone. De Jong allows action to derail, while Van Eeden shows that contemplation does not necessarily lead to a solution. In the 2007 series of drawings *Der Archeologe, die Reise des Oswald Sollmann*, the fictional archaeologist Sollmann searches for knowledge and insight in many corners of the world. Including in Delhi in India, the birthplace of Rattan Chadha. Like a mediaeval knight, Sollmann is looking for the holy grail, a noble pursuit but also a quest that does not lead to the yearned-for utopia. The black-and-white drawings underline the

melancholy that accompanies such a search, and yes, also the consolation it brings. Van Eeden zooms in on life and fate. Man seeks meaning, the universe is silent.

Art also has a moral dimension. Marc Bijl (1970) takes a straightforward approach to this quality. *PORN*, his sculpture from 2006, throws the word in your face. Has society become addicted to it, is it deliciously confused? Bijl executes the word out of all proportion, with the black letters leaving traces on the white pedestal, so-called dripping in painterly jargon.
With this image, Bijl is referring to the history of art and of society. *LOVE*, the iconic image by Robert Indiana (1928-2018) from the 1960s, with the same typography and tilted O, served as the model for *PORN*. Indiana celebrated free love, while Bijl questions the pornofication and vulgarization of society. Without raising a moralistic finger.

Just as overwhelming, confronting and morally uncomfortable as Bijl's sculpture are the sculpture group and the works on paper by Thomas Hirschhorn (1957). Hirschhorn knocks and drills nails and screws into tailor's dummies, making them look like voodoo objects. Instead of the latest fashion, they predict something ominous.

Which is only reinforced by their immobility: the dolls are glued to the ground with tape. No escape. The mannequin as a dummy, or more precisely an object onto which anyone can project anything instead of a human being made of flesh and blood, has elevated Hirschhorn to a sinister height. His works on paper do not bode well either, nor do many other works of art in this chapter. For example, the situation in the work of Gilbert & George (1943 & 1942), Grayson Perry (1960) and Raqib Shaw (1974), among others, is getting very out of hand.

The title of the painting by Hernan Bas (1978) sums up the theme of this chapter extremely well: *Two Cowards at the Monument to Courage*. Optimism is a force that helps people move forward.

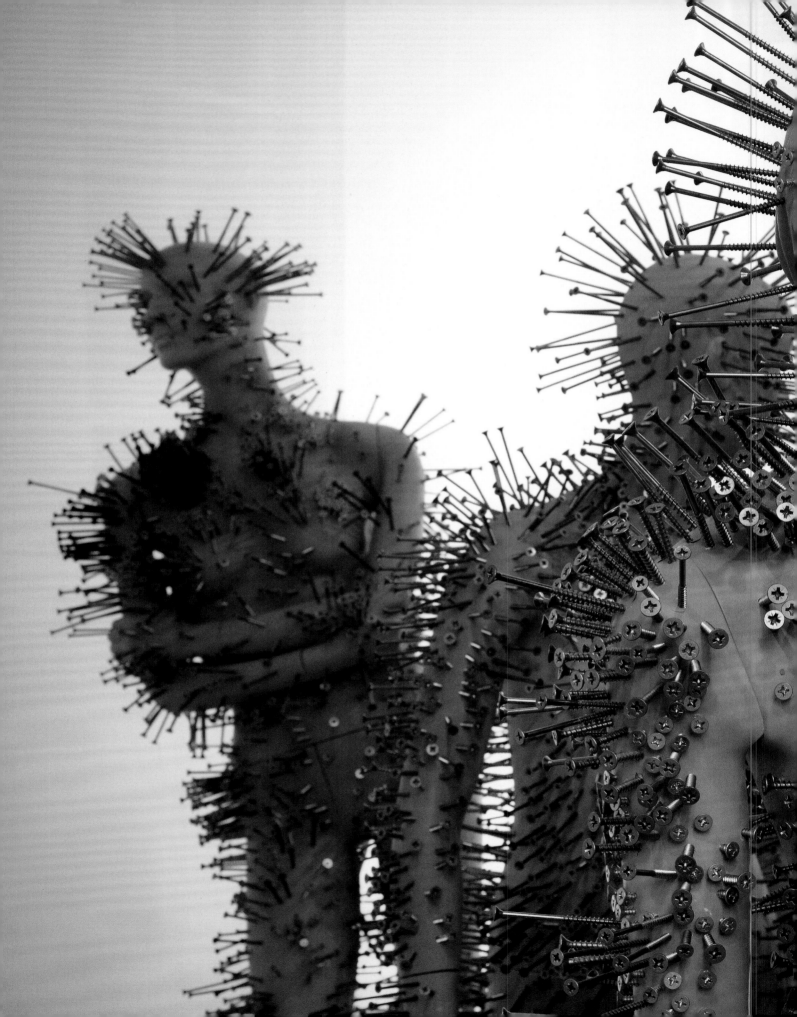

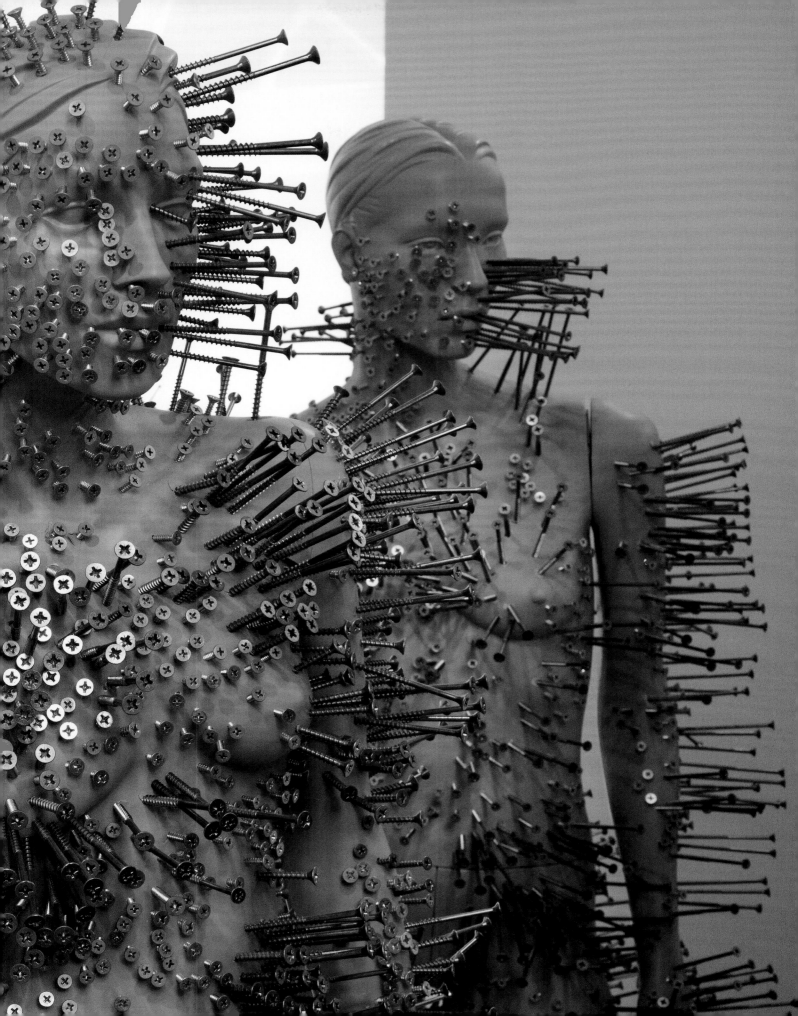

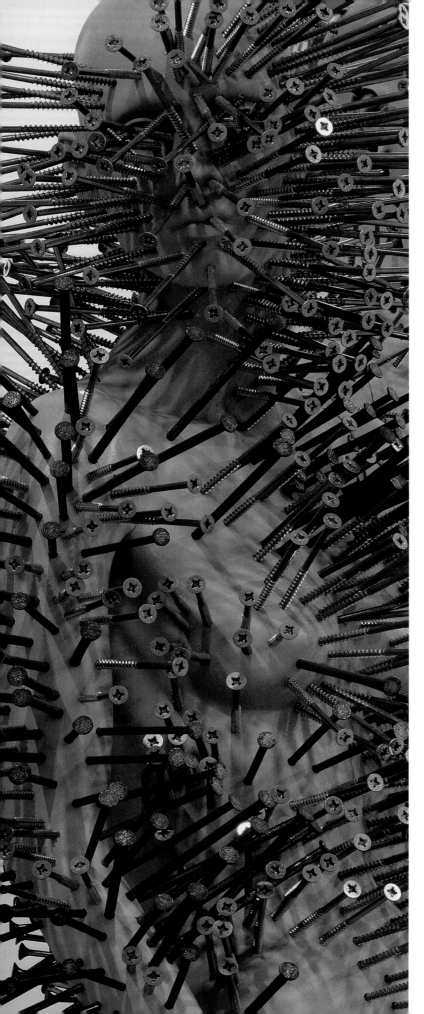

Thomas Hirschhorn
Clous-Mannequins (Colonne)
(2006)

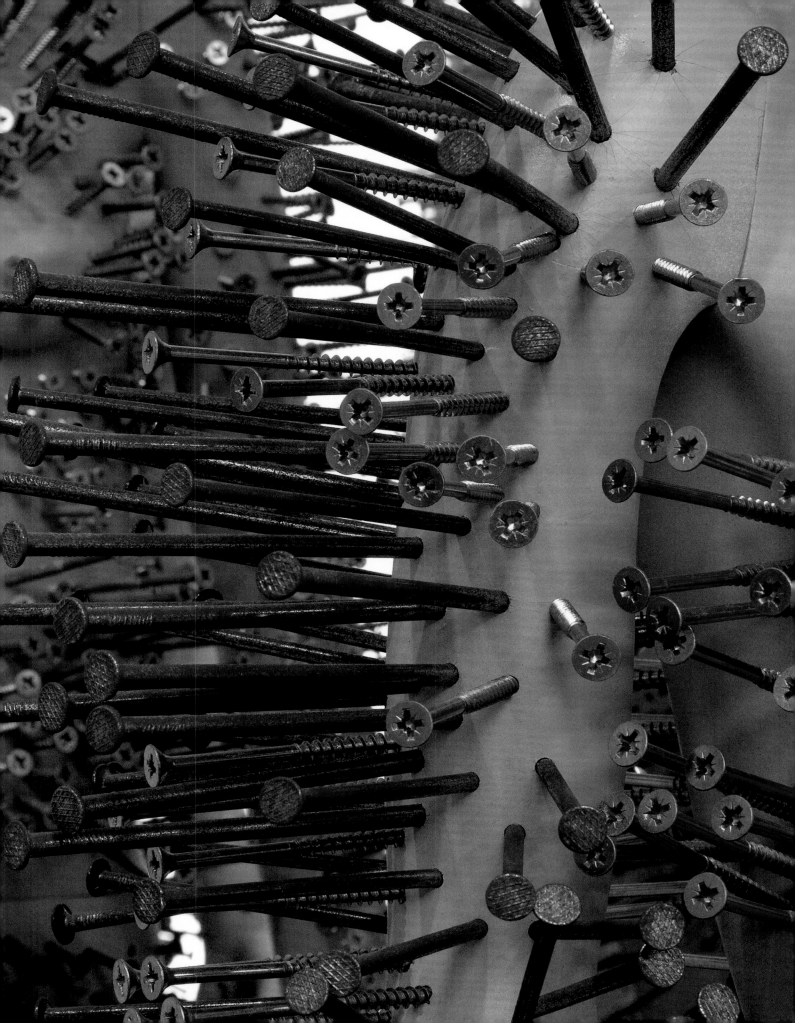

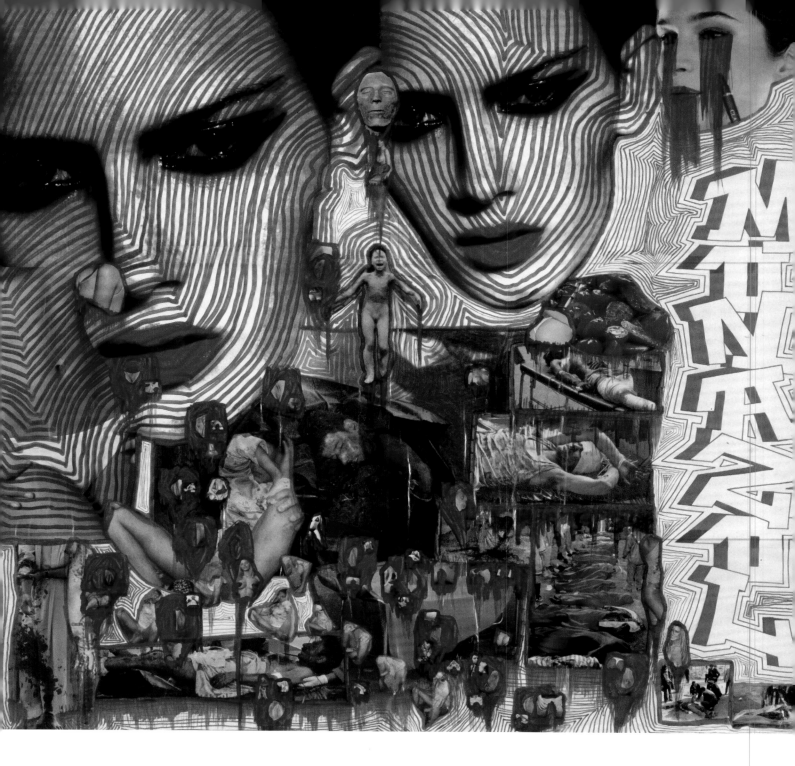

Thomas Hirschhorn
Monazol (From the series Des Antifongiques)
(2005)

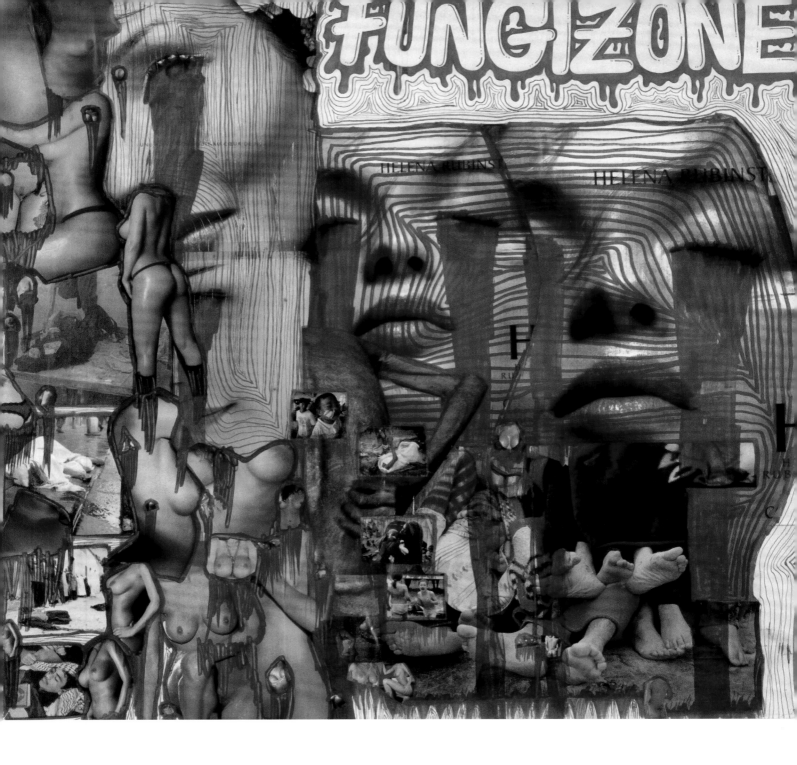

Thomas Hirschhorn
Fungizone (From the series Des Antifongiques)
(2005)

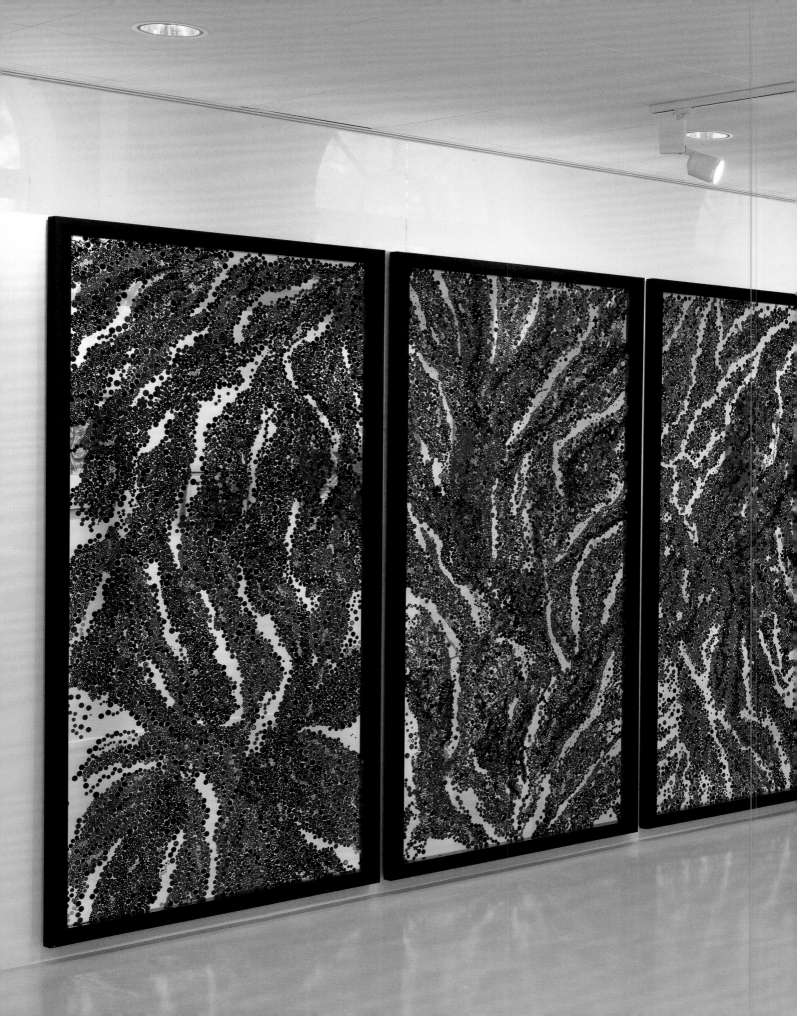

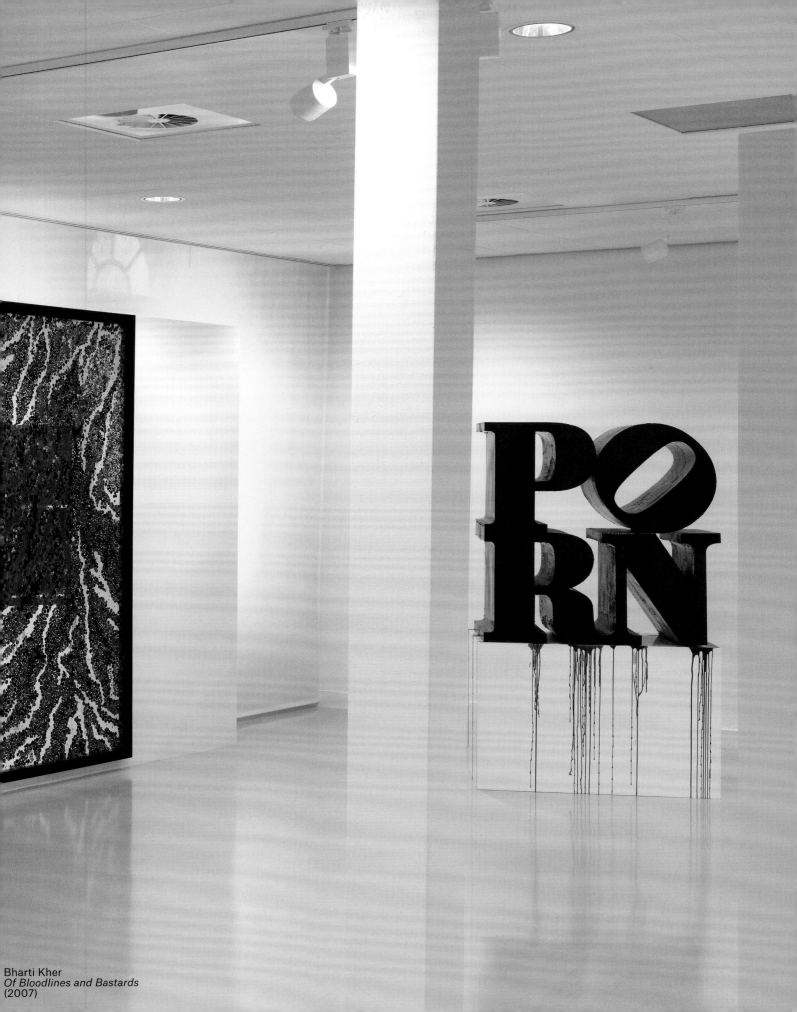

Bharti Kher
Of Bloodlines and Bastards
(2007)

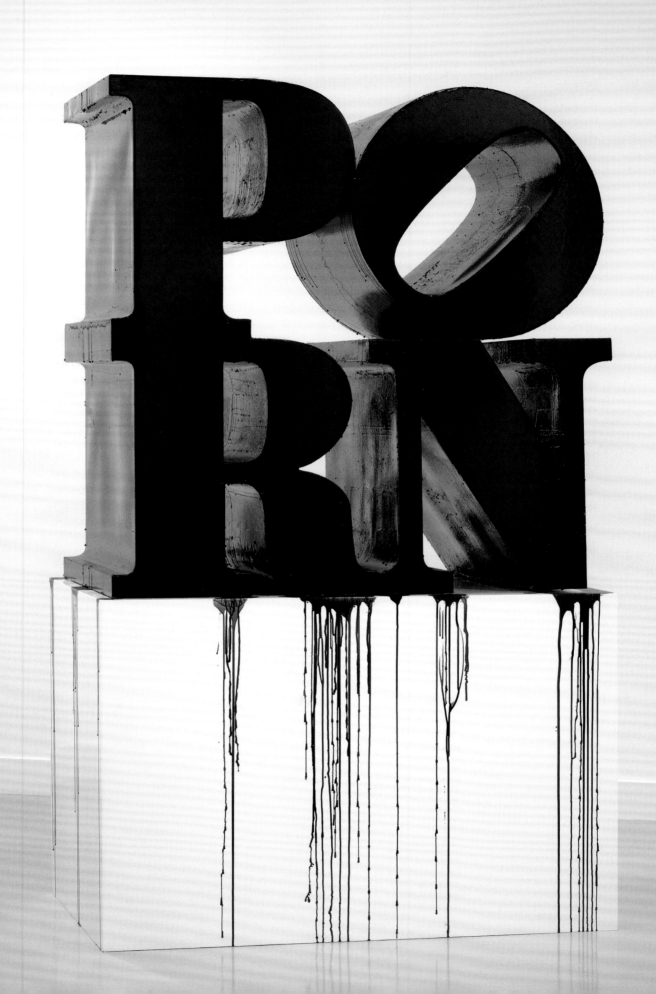

Subodh Gupta
Black Skin White Mask
(2011)

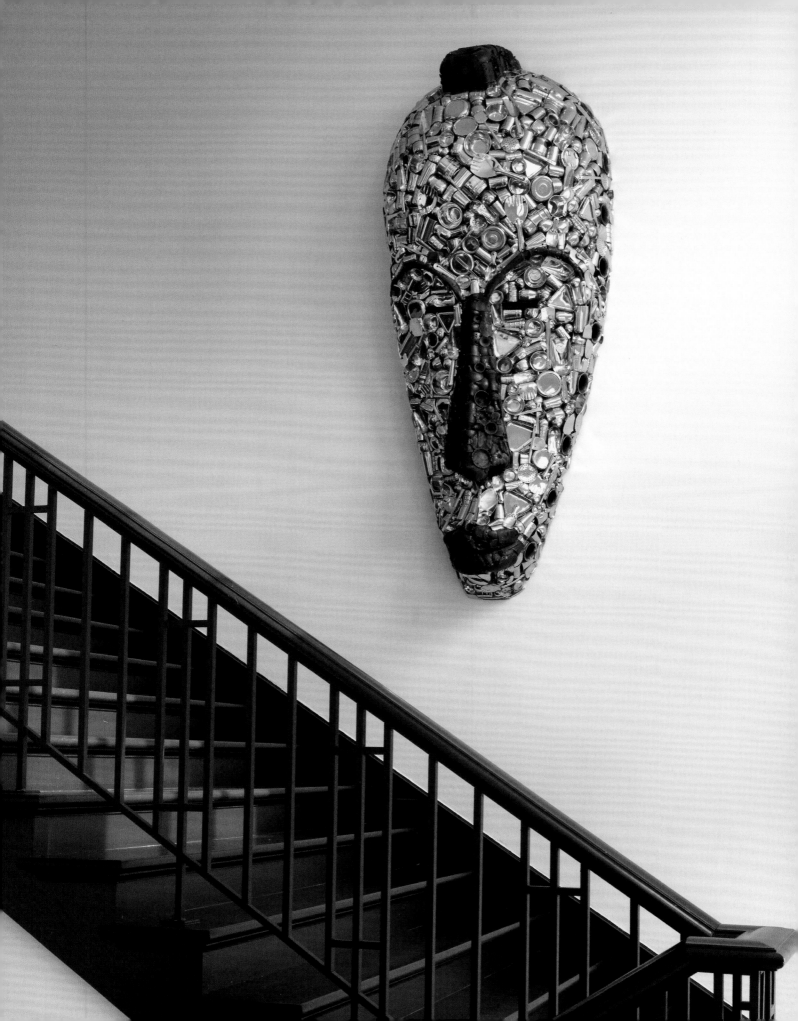

Rita Ackermann
Cold Turkey with Bonbons
(1993)

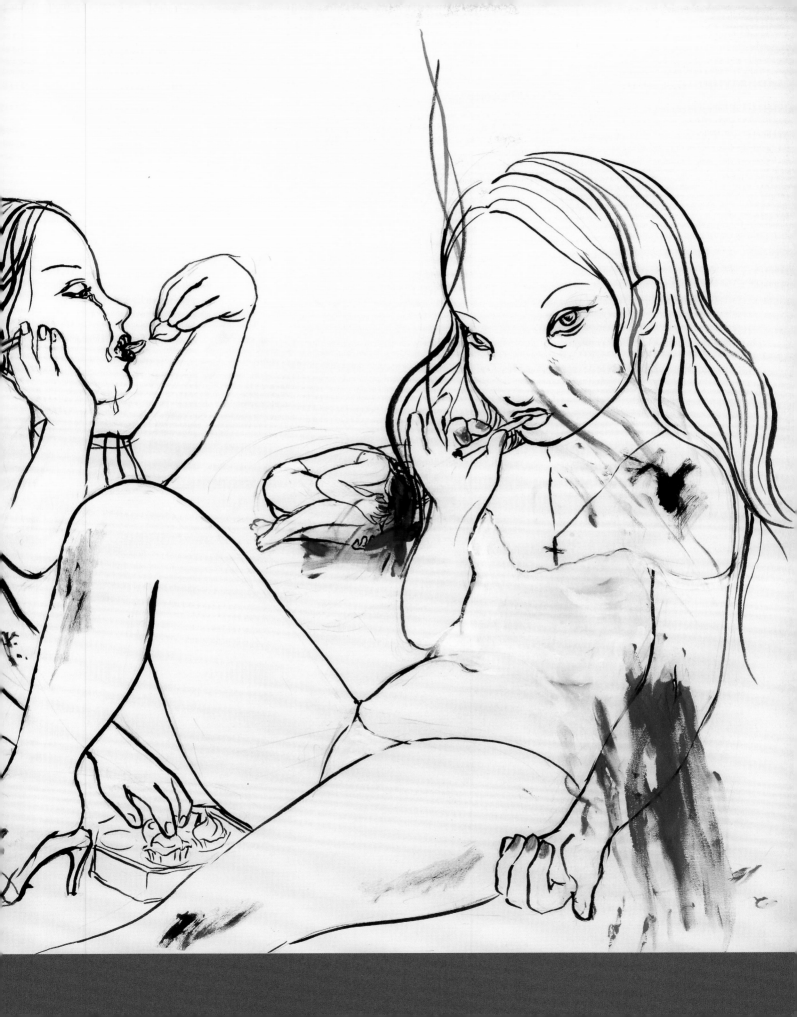

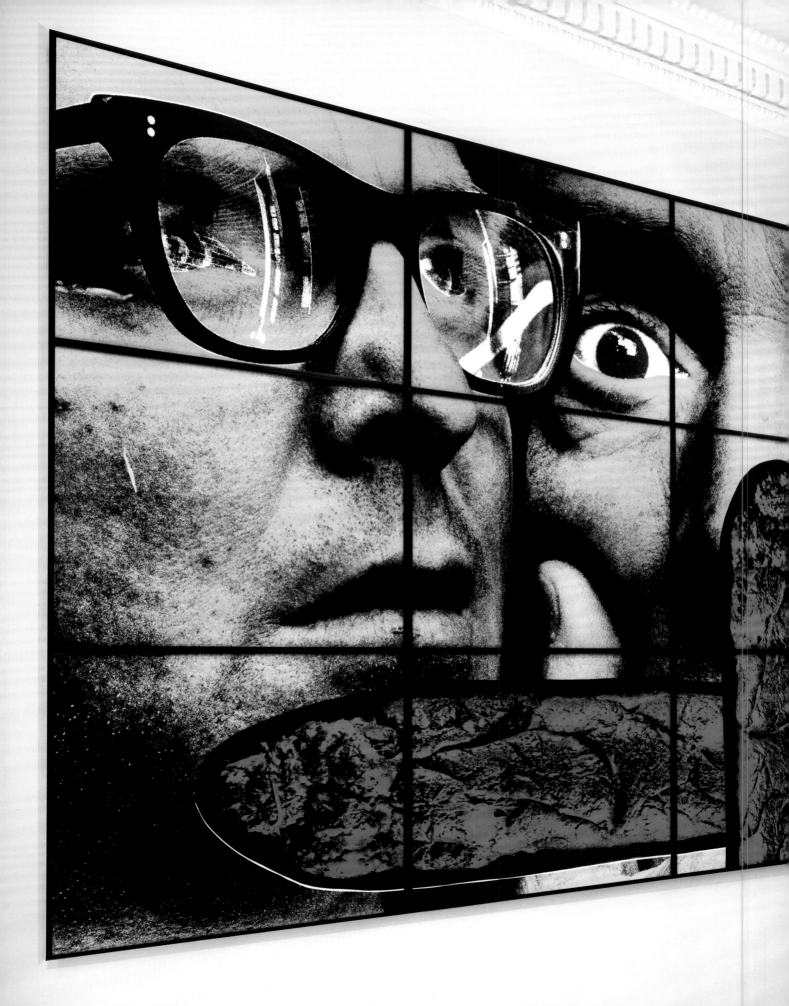

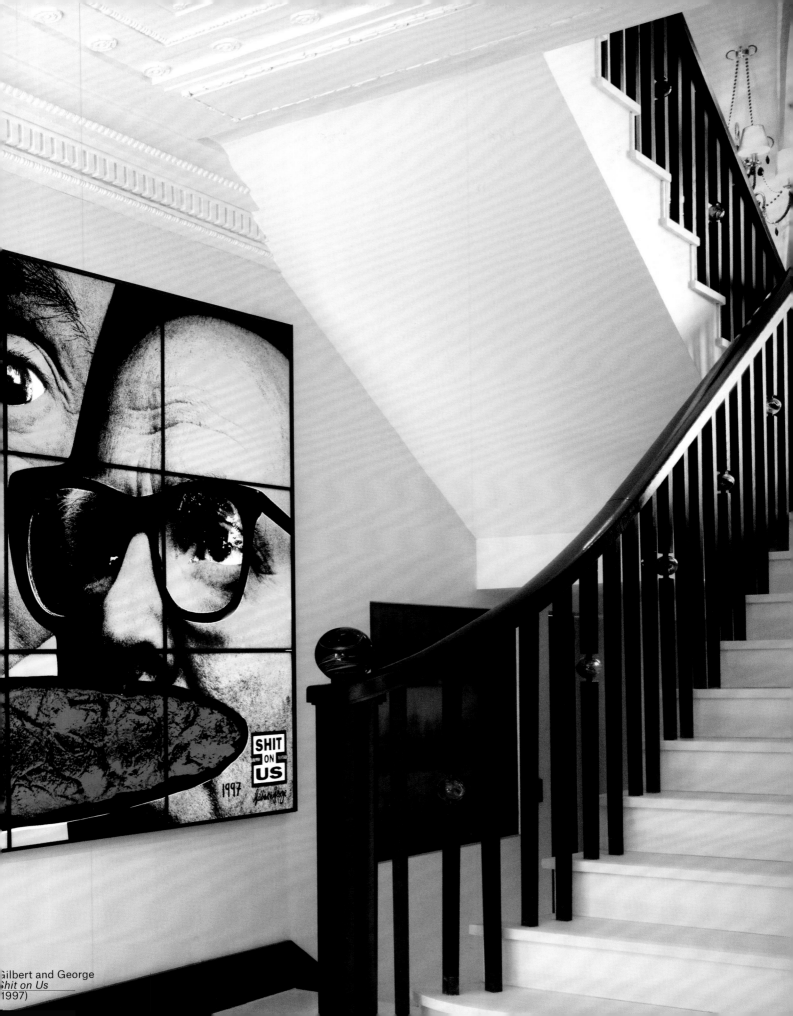

Gilbert and George
Shit on Us
(1997)

82

Raymond Barion
Carpet (Egypt)
(1987)

Marcel van Eeden
Der Archeologe, die Reise des Oswald Sollmann

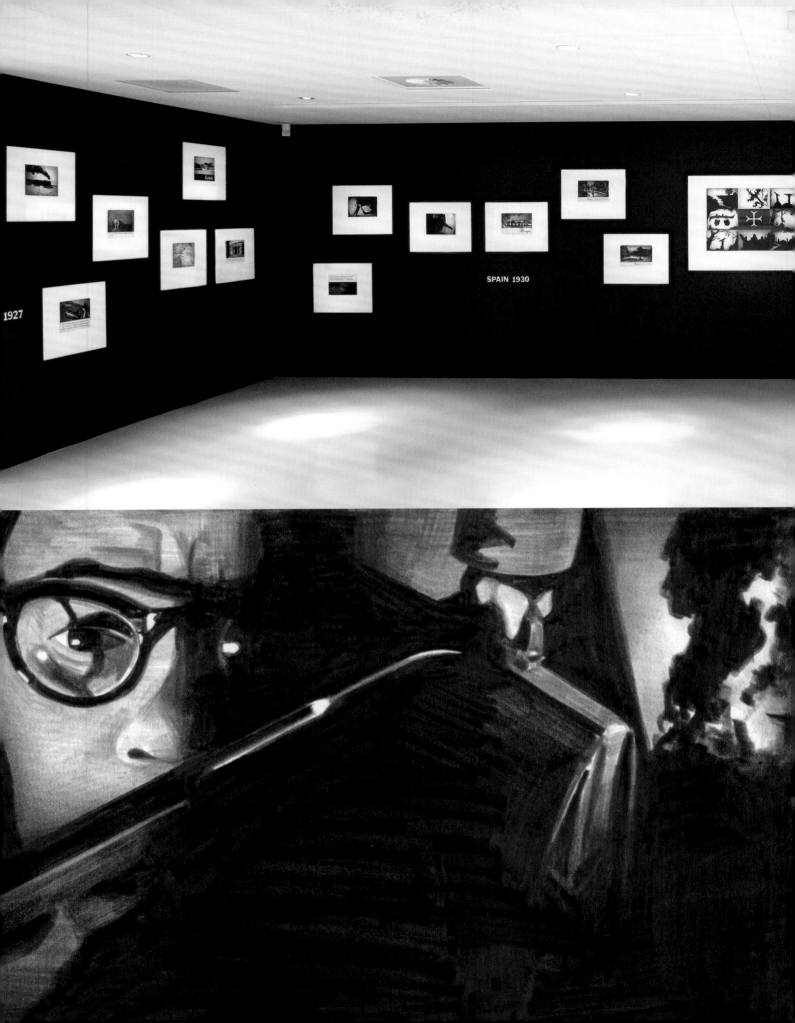

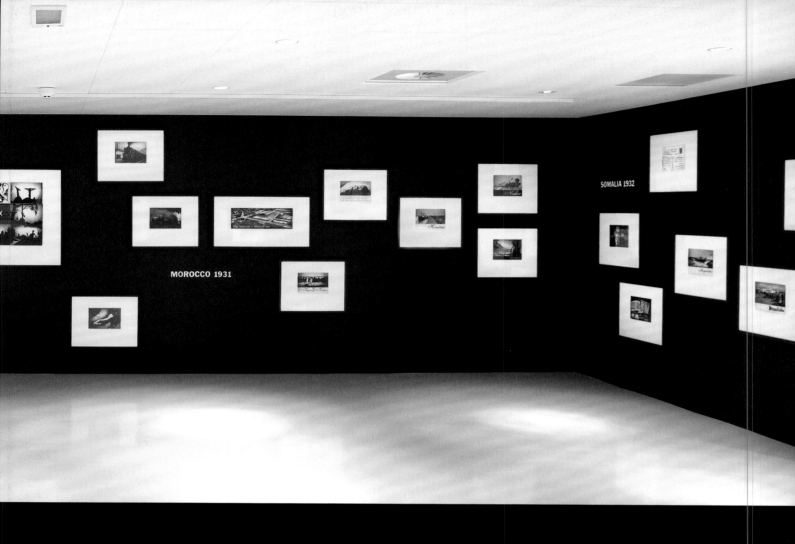

MOROCCO 1931

SOMALIA 1932

Marcel van Eeden
Der Archeologe, die Reise des Oswald Sollmann
(2007-2008)

I assure you that in this kingdom justice is very
strictly administered to those who commit homicide
or theft or any other crime. Concerning debts the
following rule and enactment is observed among

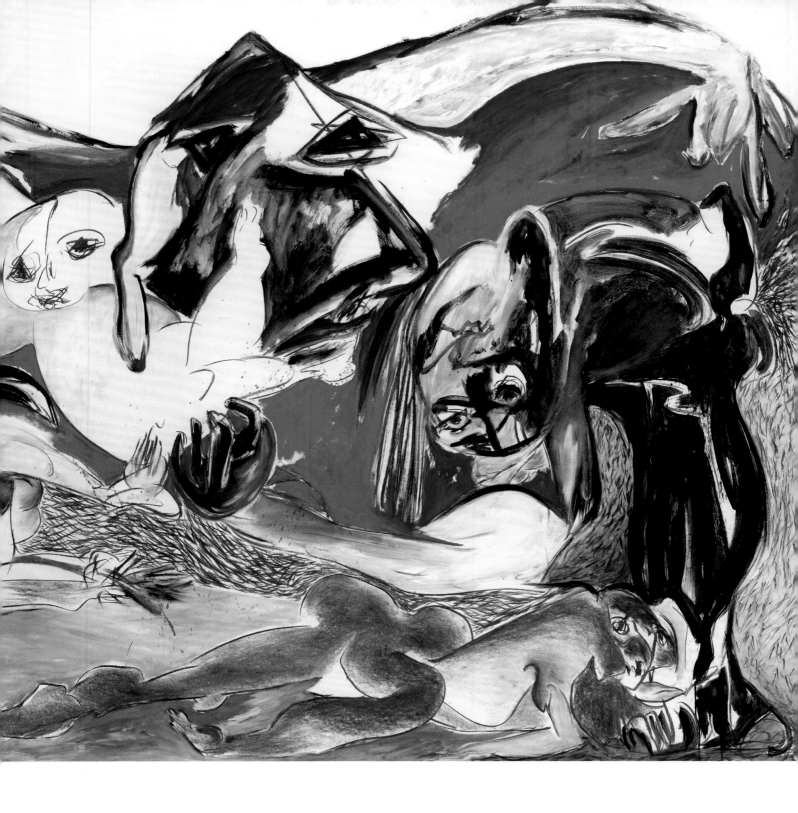

Jacqueline de Jong
La Garantie Pousse
(1996)

Jacqueline de Jong
La Garantie Pousse
(1996)

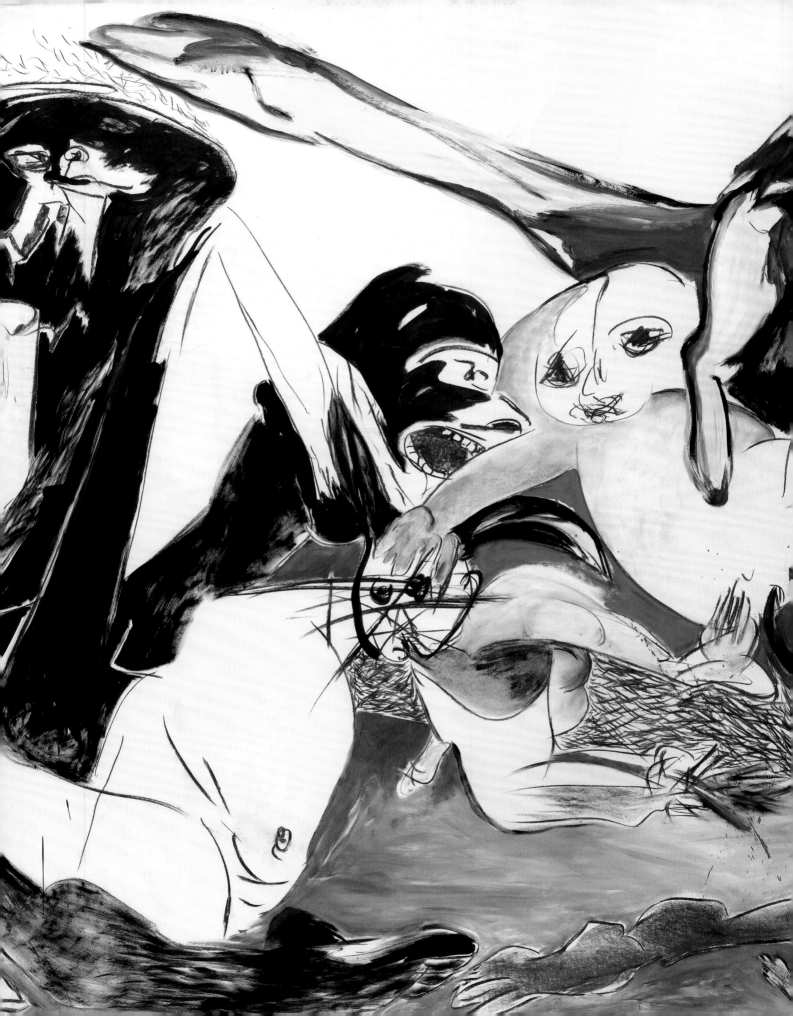

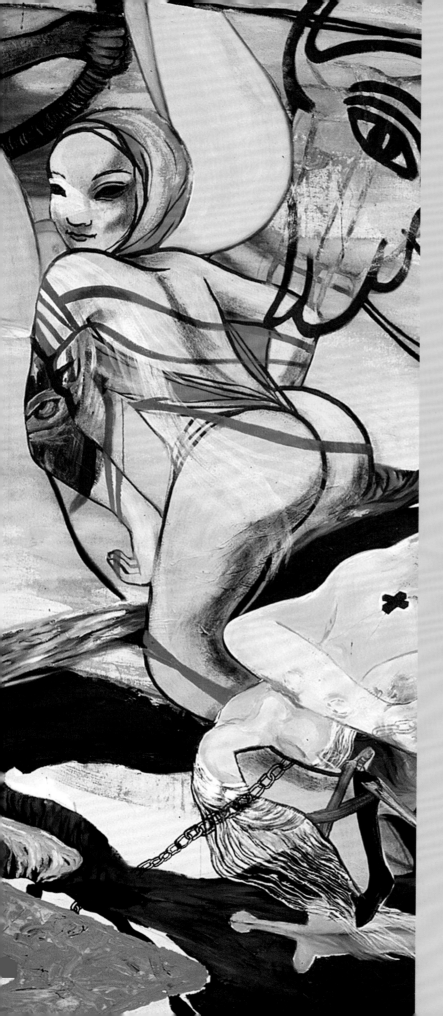

DELICIOUS
CONFUSION

Instinctively, the human race aspires to better or more and everyone wants to move onwards or upwards, which inevitably sometimes leads to delightfully confusing situations. Impulses often stand in the way of well-considered perspectives. The higher heroism that can derail is discussed in this chapter of Rattan Chadha's art collection.

The figures in Folkert de Jong's (1972) installation show ambition. In a grotesque way the king, emperor and admiral discuss how to conquer or divide up the world. Under a chandelier, on a raft floating on oil drums, with the gun and knife on the table. When grand plans are being forged with great drive, the nightmare is never far away. In the past and present. Folkert de Jong's work is a shout while Marcel van Eeden (1965) brings his insight to the fore in a whispered tone. De Jong allows action to derail, while Van Eeden shows that contemplation does not necessarily lead to a solution. In the 2007 series of drawings *Der Archeologe, die Reise des Oswald Sollmann*, the fictional archaeologist Sollmann searches for knowledge and insight in many corners of the world. Including in Delhi in India, the birthplace of Rattan Chadha. Like a mediaeval knight, Sollmann is looking for the holy grail, a noble pursuit but also a quest that does not lead to the yearned-for utopia. The black-and-white drawings underline the

HER MANNER WAS SO EASY, SO ARTLESS AND PLEASING, HE COULD NOT BELIEVE IT AN ACT, THOUGH SHE PERFORMED IT WELL. HE LIT TWO WHILE SHE POURED VODKA AND PEPSI-COLA AS IF THEY WERE FROM THE SAME BOTTLE.

Raymond Pettibon
No Title (Her manner was...)
(2013)

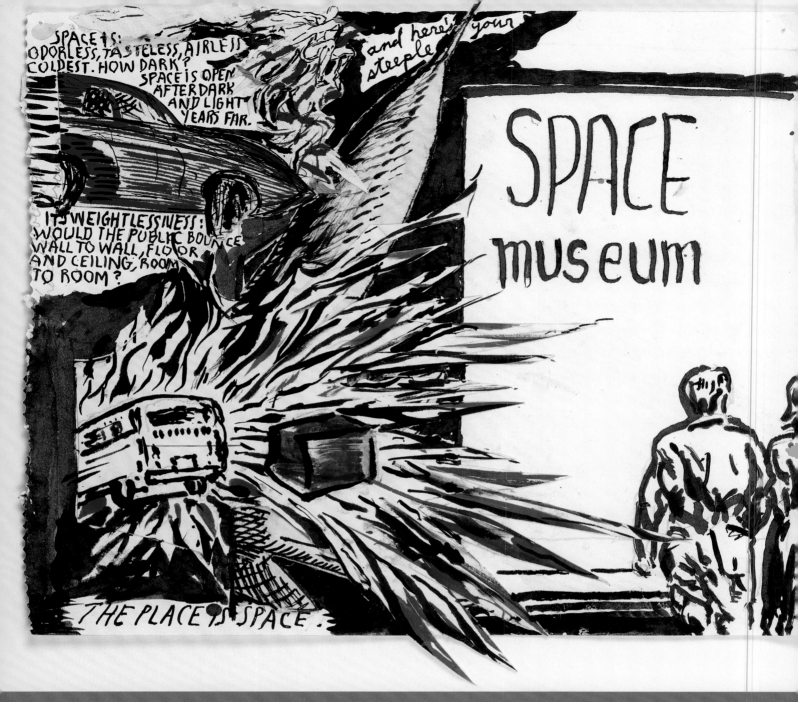

THE OPPOSITE WALL WAS COVERED BY A
MIRROR, WHICH MADE THE ROOM APPEAR
BIGGER THAN IT ACTUALLY WAS.

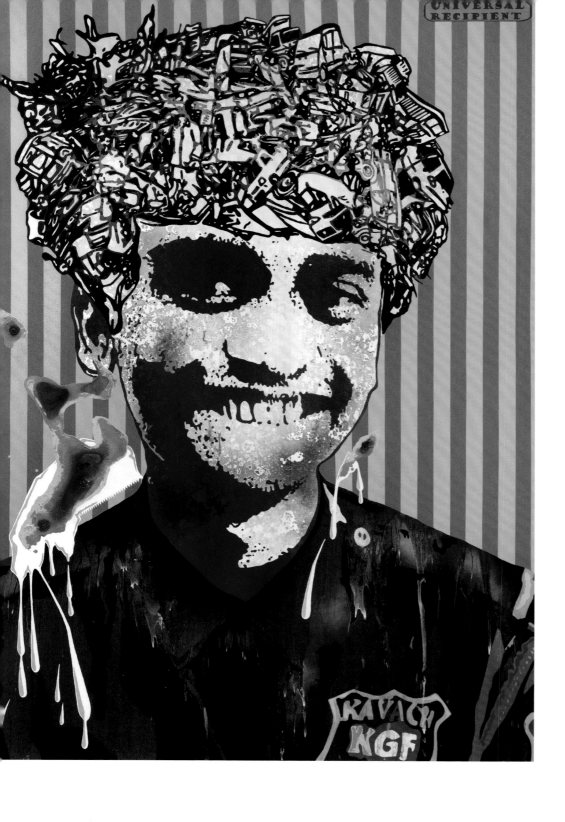

Jitish Kallat
Universal Recipient
(2008)

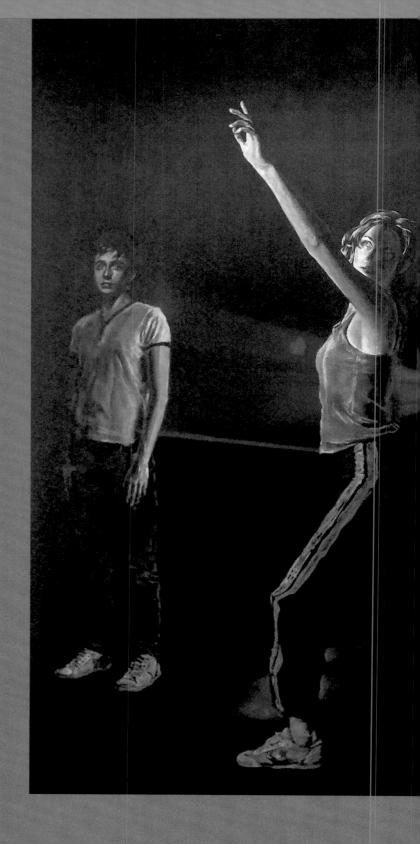

Muntean/Rosenblum
Untitled ('Wherever they looked...')
(2016)

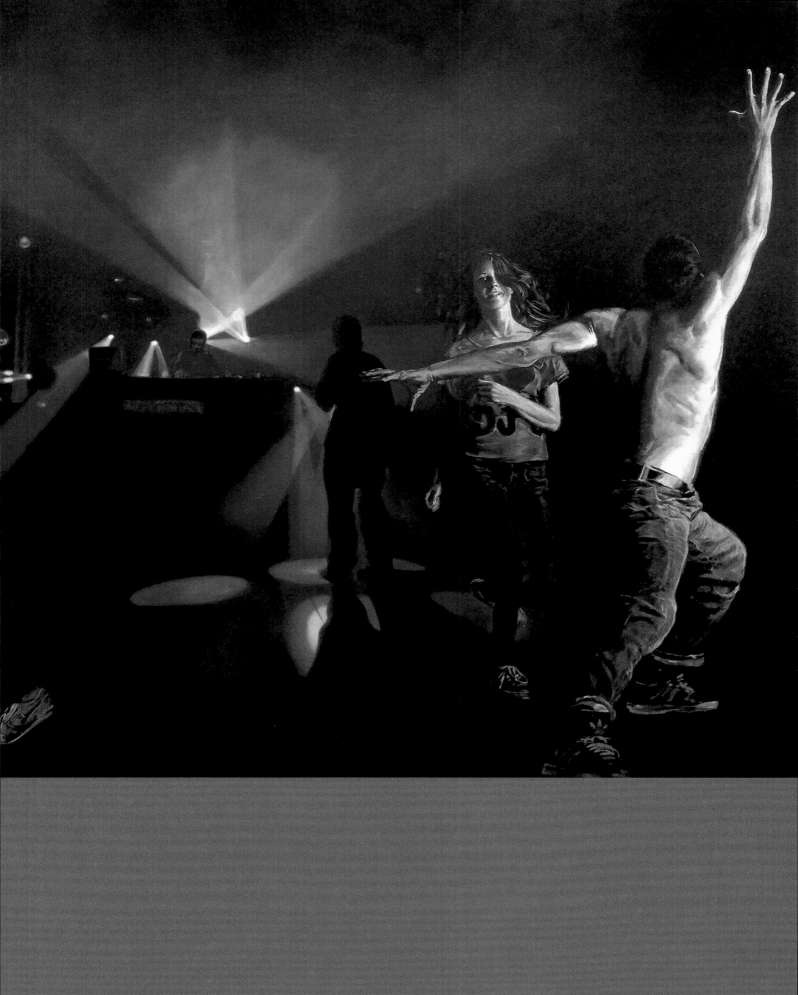

Jen Liu
The Brethren of the Stone: Vista ex Machina
(2007)

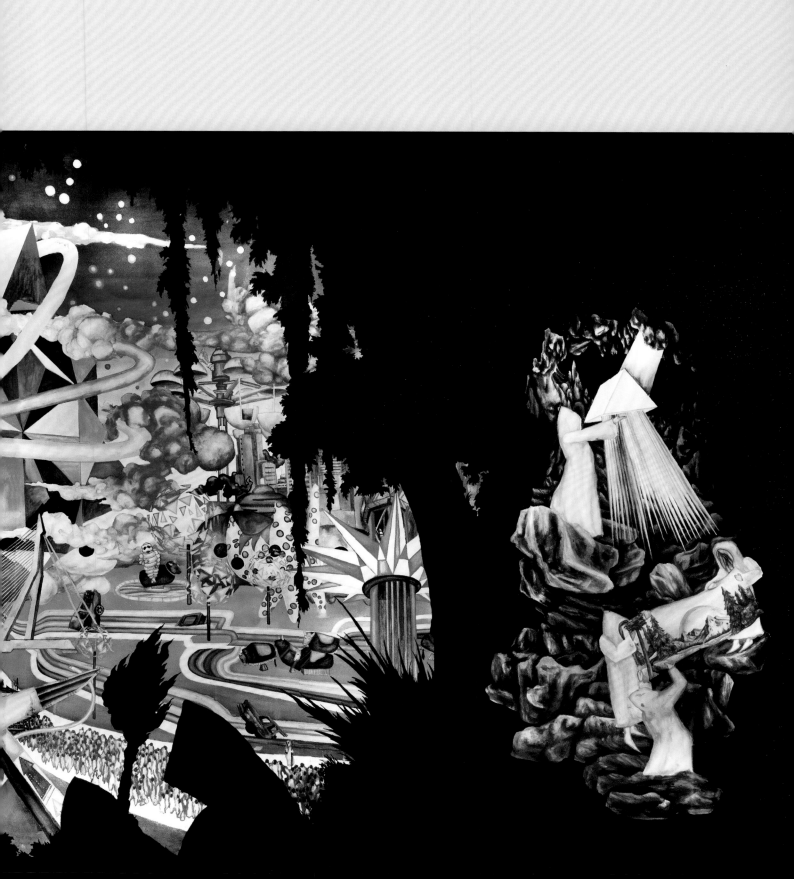

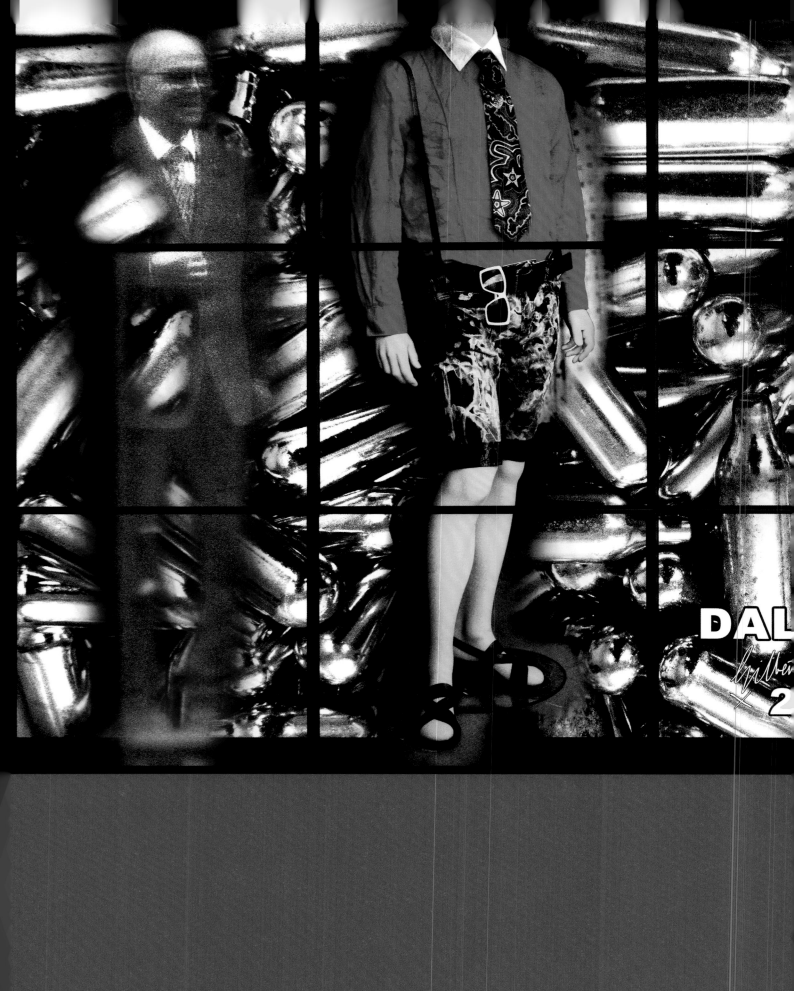

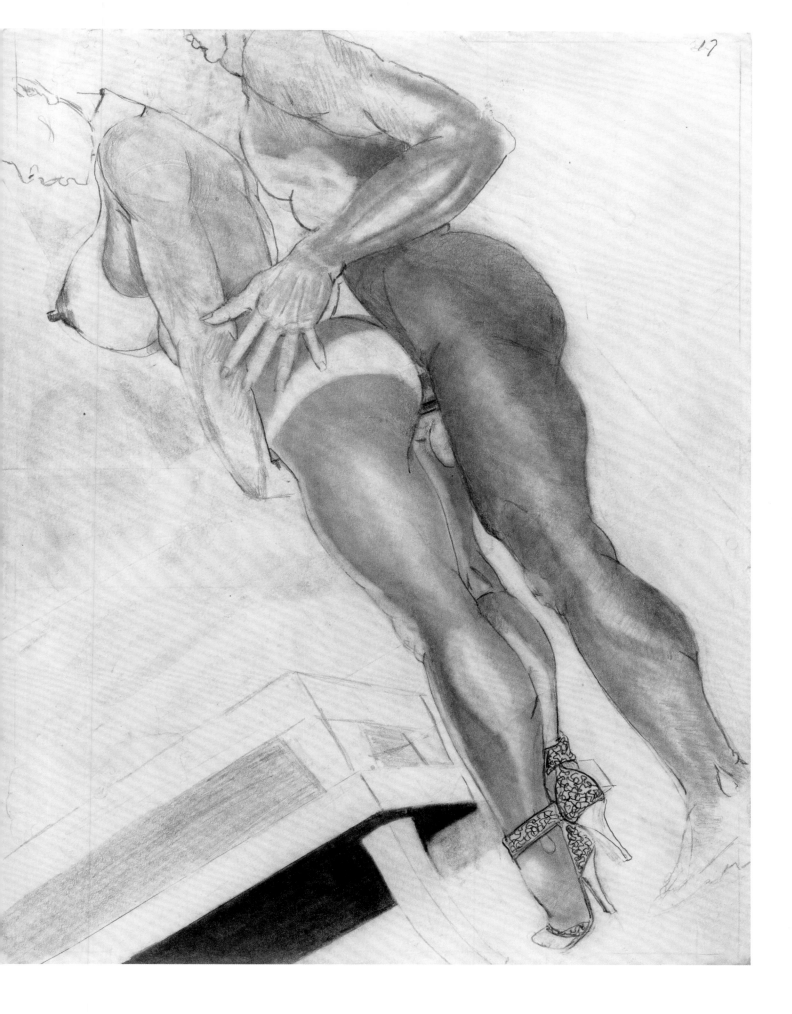

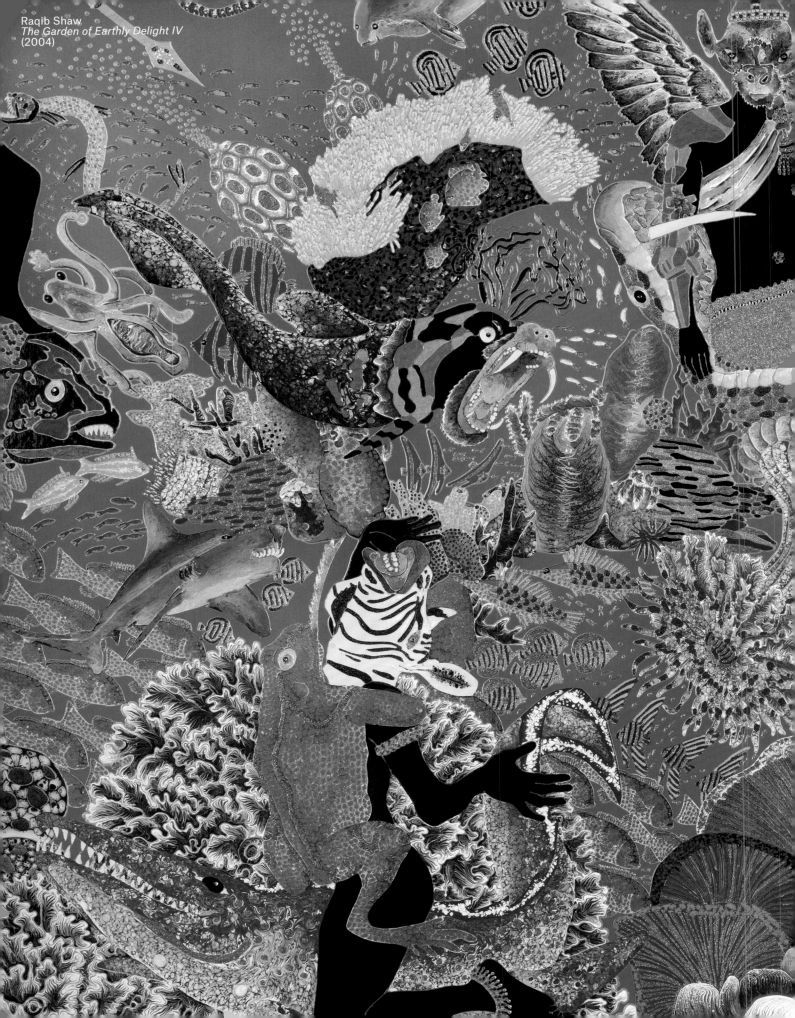

Raqib Shaw
The Garden of Earthly Delight IV
(2004)

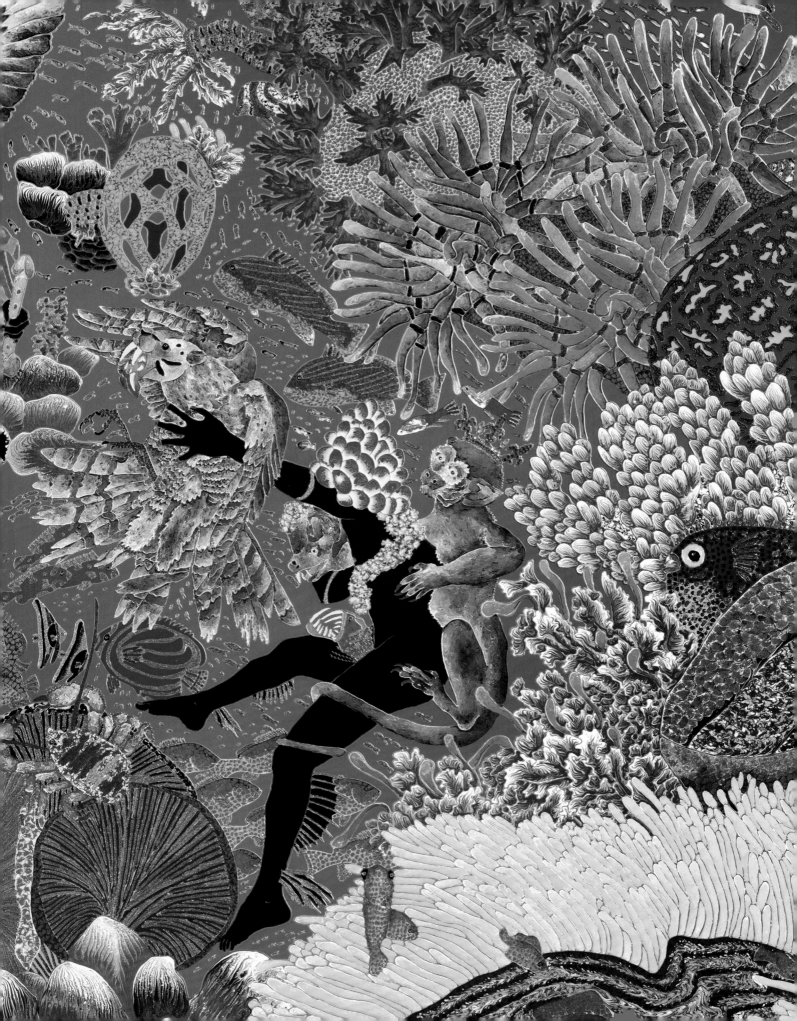

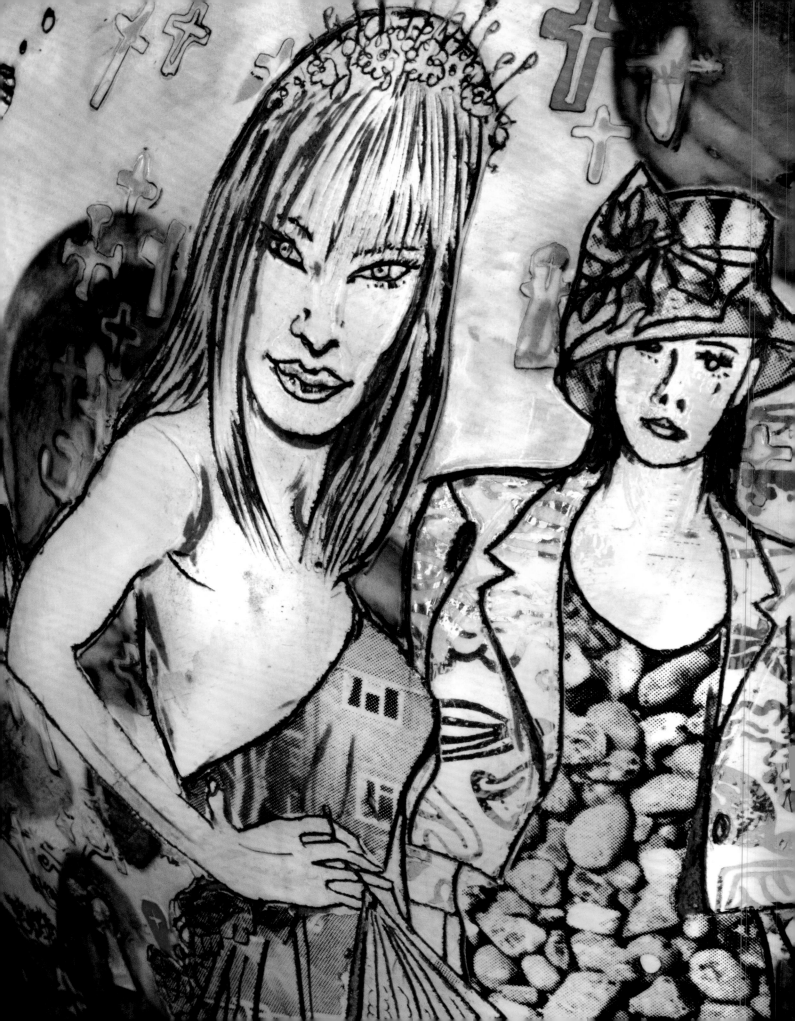

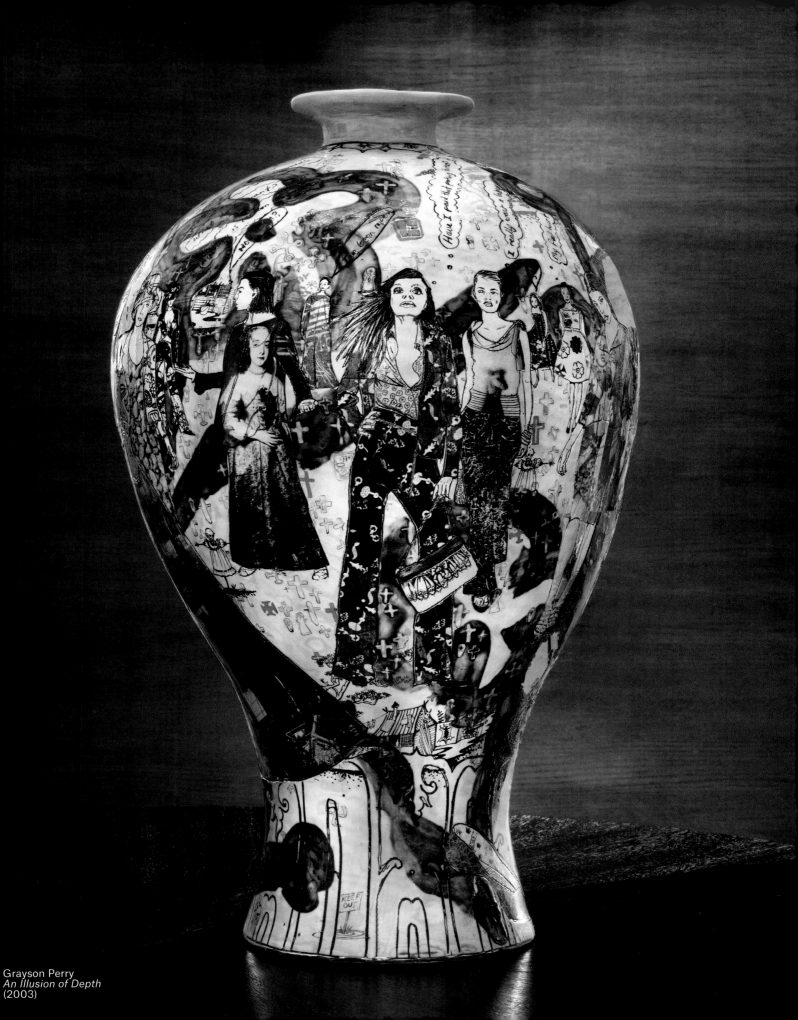

Grayson Perry
An Illusion of Depth
(2003)

Grayson Perry
Assembling a Motorcycle from Memory
(2004)

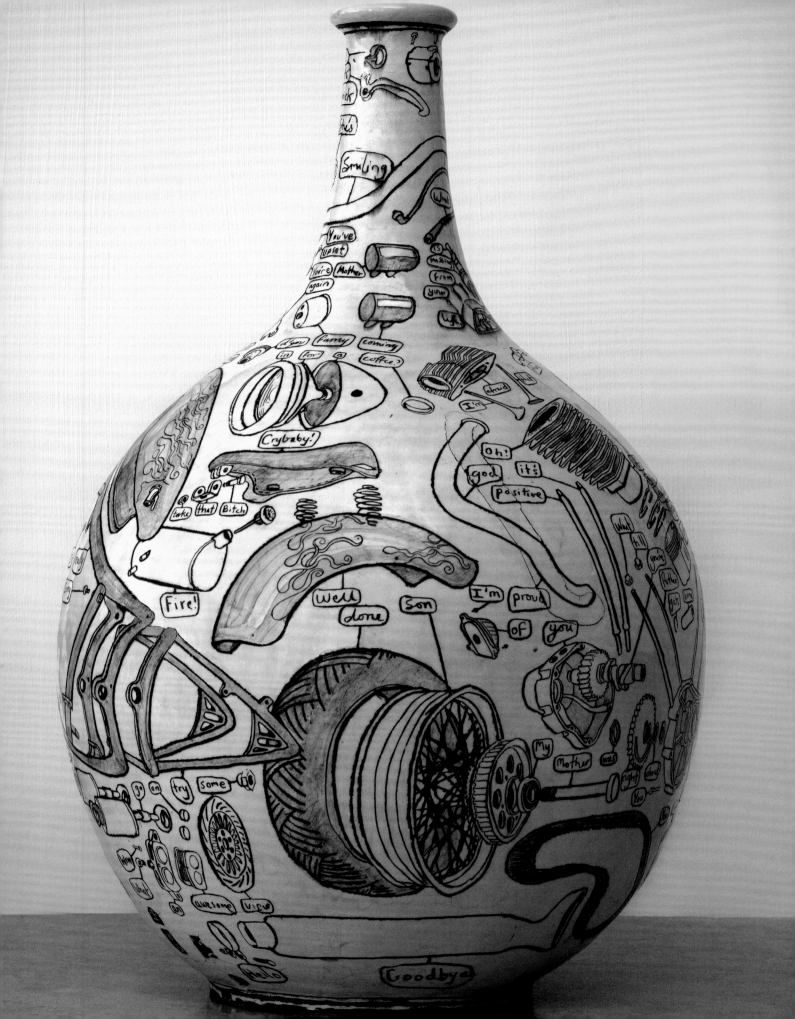

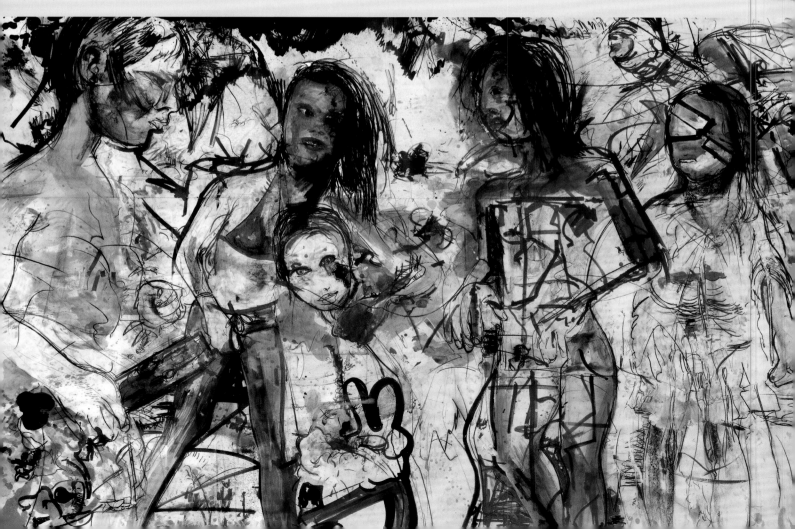

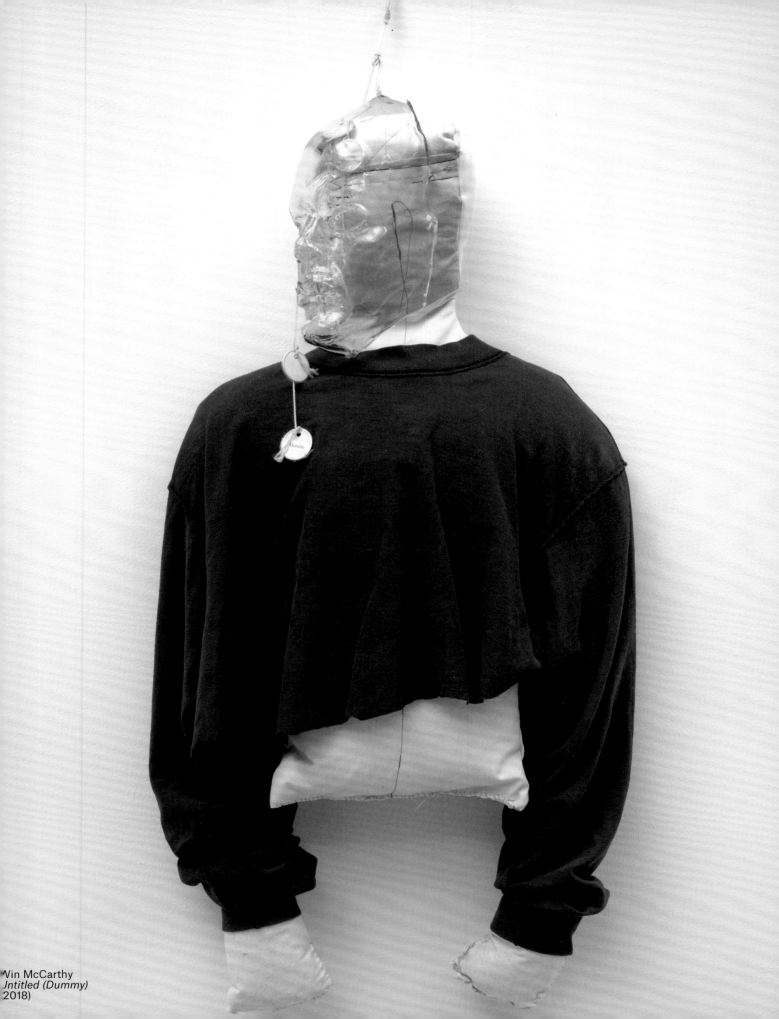

Win McCarthy
Untitled (Dummy)
2018)

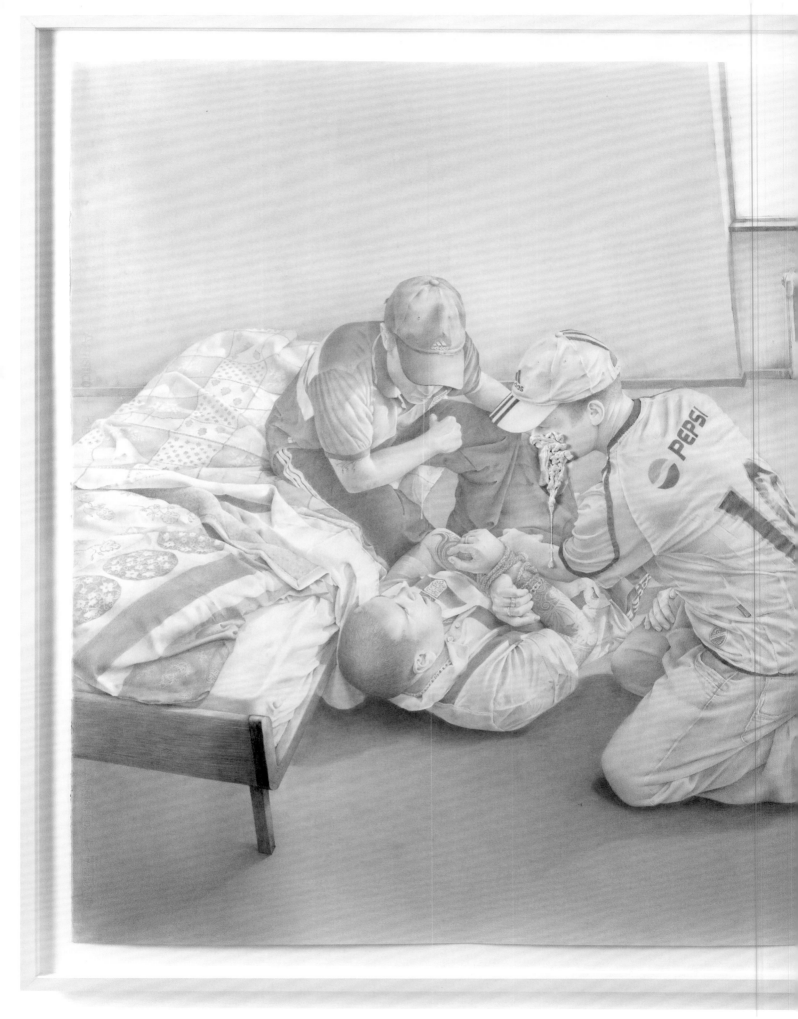

David Haines
Dissolving Prophesies
(2007)

→
David Haines
Meatboy and Bob Starr
(2016)

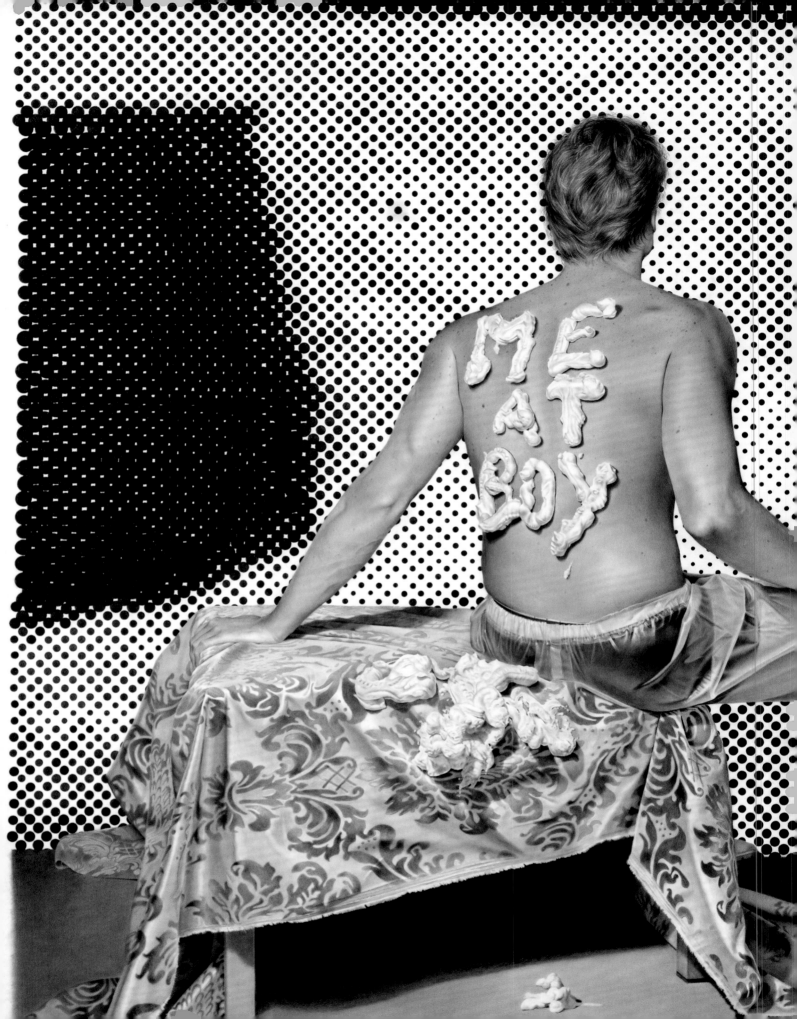

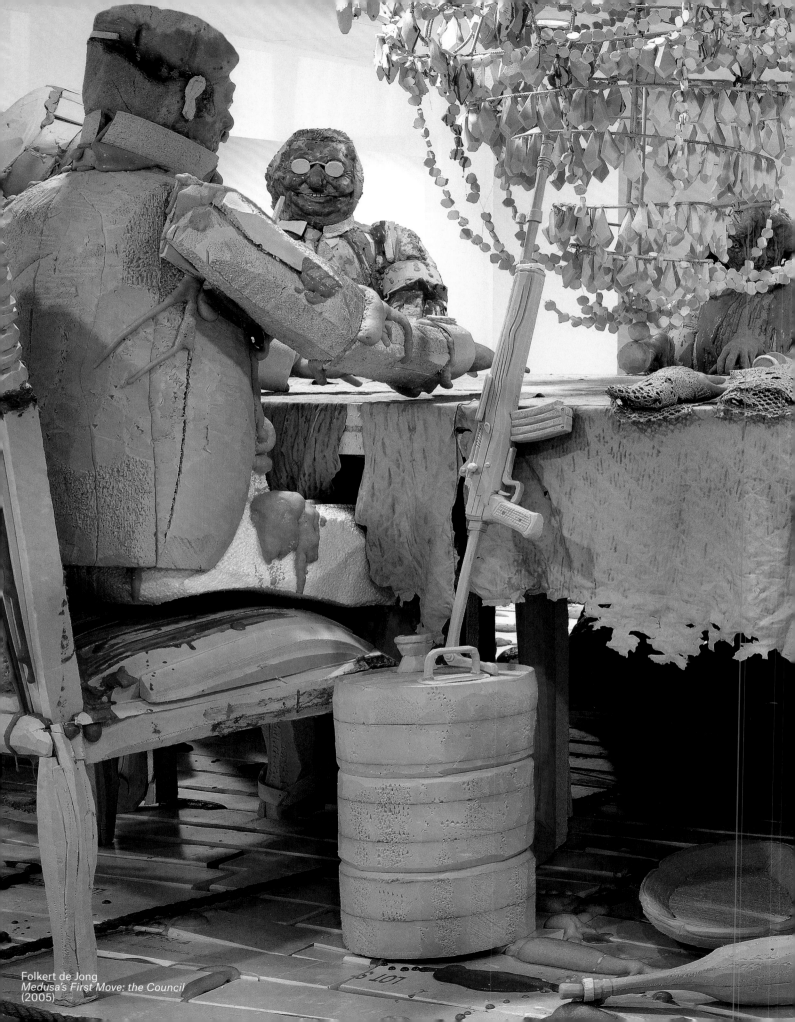

Folkert de Jong
Medusa's First Move: the Council
(2005)

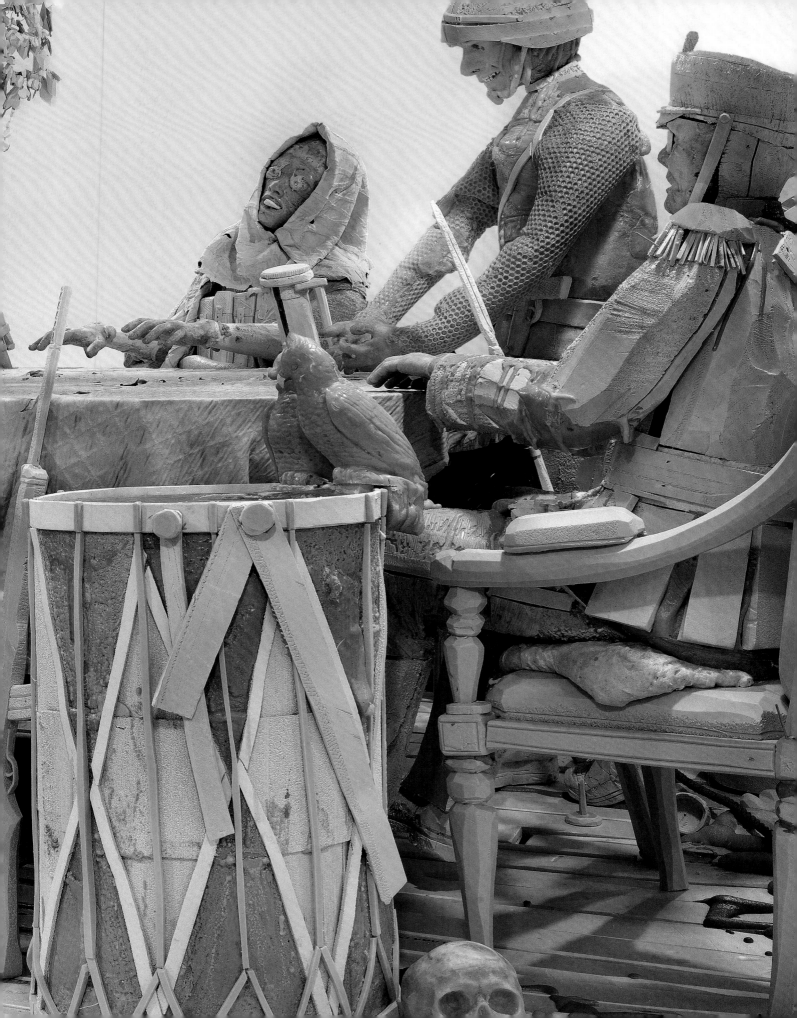

FOREVER YOUNG

Staying alert is an important motivation in our existence. 'May you always be courageous/ Stand upright and be strong/ May you stay forever young,' sang Bob Dylan in 1974. This mentality plays a central role in this chapter of Rattan Chadha's art collection.

Nowadays, being young in spirit and keeping up with the times primarily means embracing technological innovations, or even better: making them your own. New technologies add an unknown reality to the existing one. The influence of algorithms, virtual reality and artificial intelligence on our understanding of humanity can no longer be denied. Some philosophers even claim that we have entered a post-humanist and post-Darwinian era, because the human race has taken control of its own evolution.

The eternal life that is being realized in the here and now is addressed in the installations by Rafaël Rozendaal (1980) and Ian Cheng (1984). Rozendaal utilizes the World Wide Web (www) as a universe where perfectly organized chaos reigns. Instead of words he uses colours and shapes. And in this installation mirrors as well, so that Plato's cave and life in the shadow come into the picture. Ian Cheng creates a completely different,

but equally overwhelming, parallel and timeless virtual world. The merry-go-round of life in which man is dissolved like a lump of sugar in tea. The new reality is not accepted blindly.

Funda Gül Özcan (1984) depicts the new, as yet unknown universe in the form of funfair dioramas, traditionally a way of evoking a world that has been lost. With her playful and colourful works she drags us to the eye of the storm, the ubiquitous spectacle that the artist actually wants to challenge. The brothers Florian and Michael Quistrebert (1984 and 1976) operate with similar visual violence. They are infectiously inappropriate. By grotesquely enlarging the gesture of painting. By using unorthodox materials such as LED lights and putty. Bob Eikelboom (1991) joins in with this by letting all the images that come to us every day reach him. He does not distinguish, he does not create a hierarchy, but invites everyone, as it were, to change everything again. In contrast, there is the silence, the almost religious experience Frank Ammerlaan (1979) achieves in his paintings. He presents the painting as a physical and transcendental experience. Comparable to the sensation of the moment you shake the hand of someone you don't know yet.

The recently deceased Jack Whitten (1939-2018) was an artist who constantly kept up with the times. Many artists perfect the theme they once chose; Whitten always came up with something new. He never lost his antenna for change. And is therefore an example for the latest generation of artists. He is as timeless as Francis Picabia (1879-1953). Both artists stayed true to themselves and went their own way.

Forever Young holds a promise for the future.

Florian & Michael Quistrebert
Collage II
(2017)

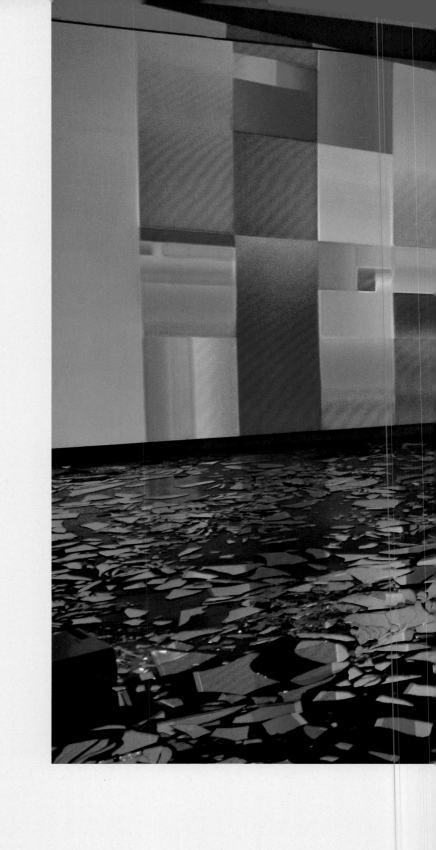

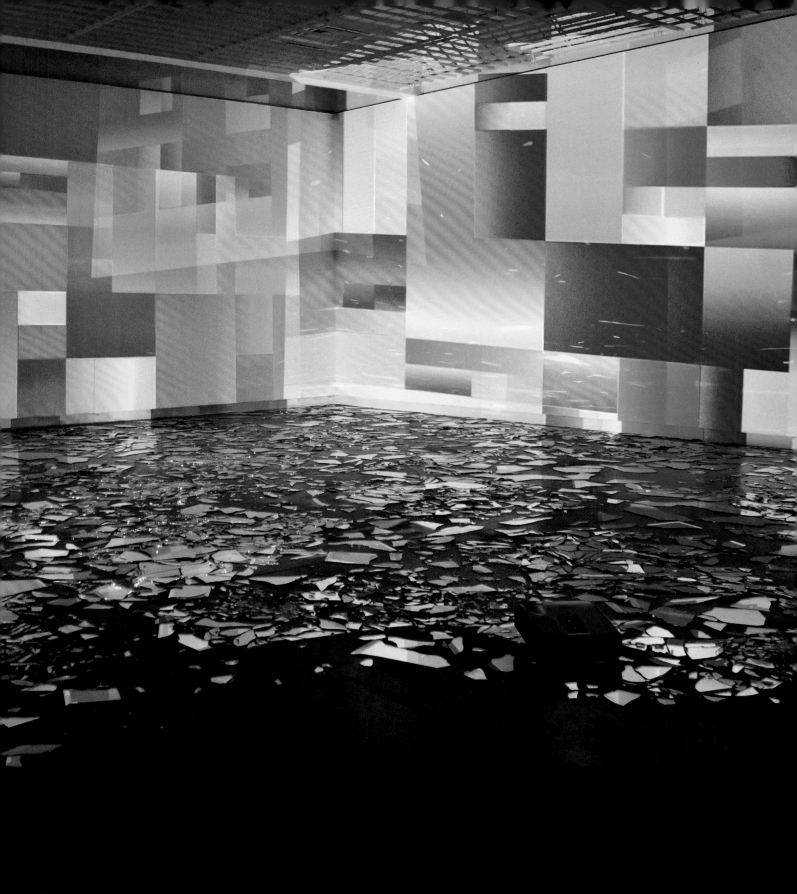

Rafaël Rozendaal
Random Fear (with Mirrors)
2019)

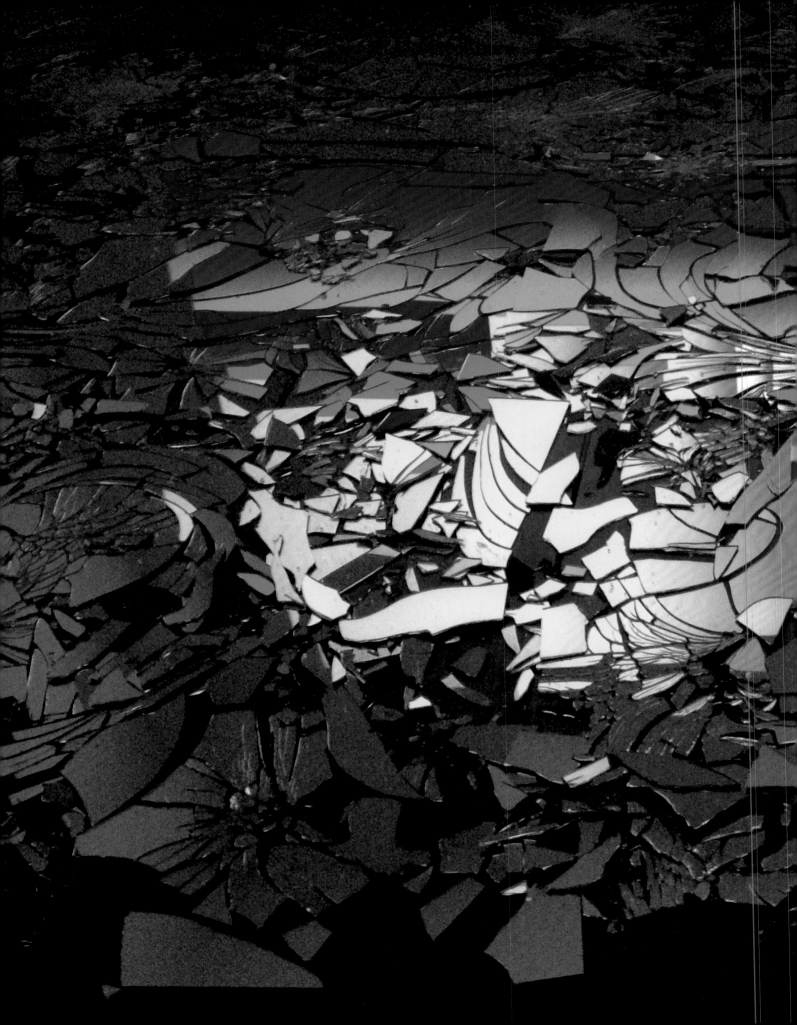

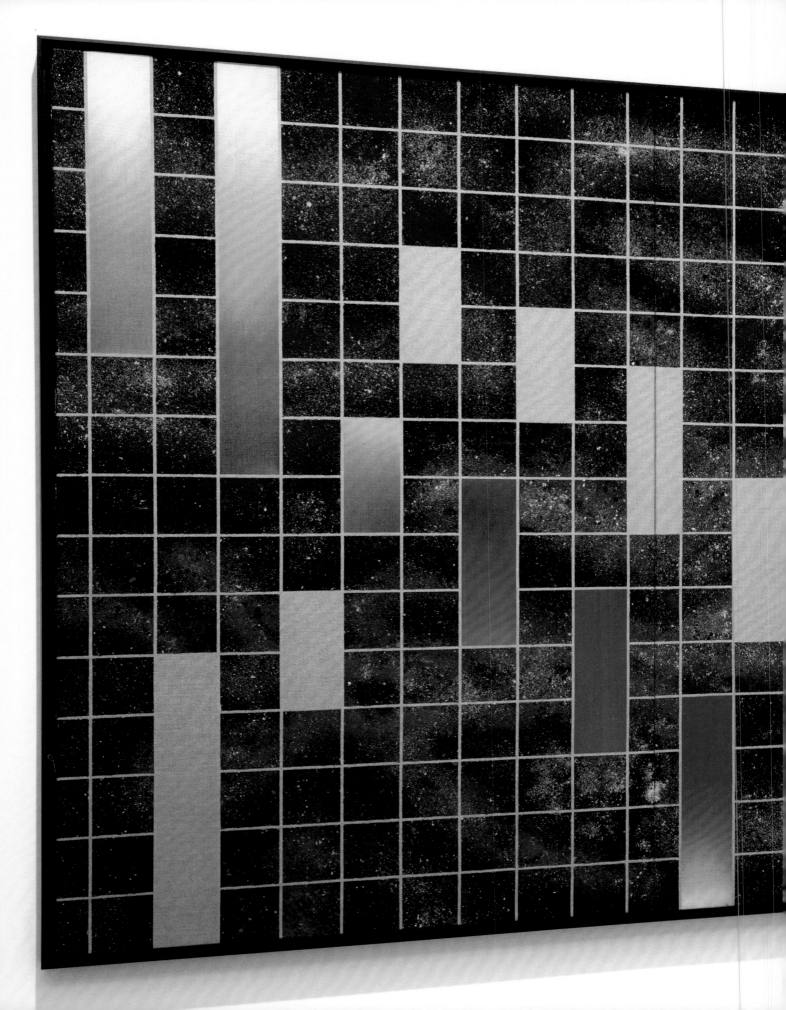

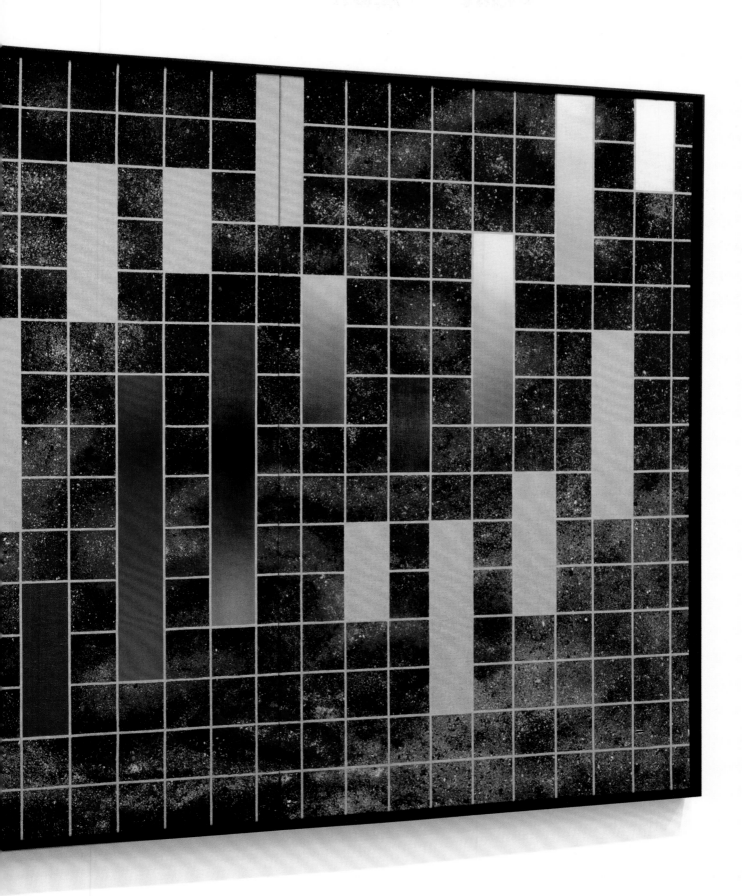

Frank Ammerlaan
Untitled
(2018)

Florian & Michael Quistrebert
Gold 1
(2015)

Cory Arcangel
Celebs / Lakes
(2015)

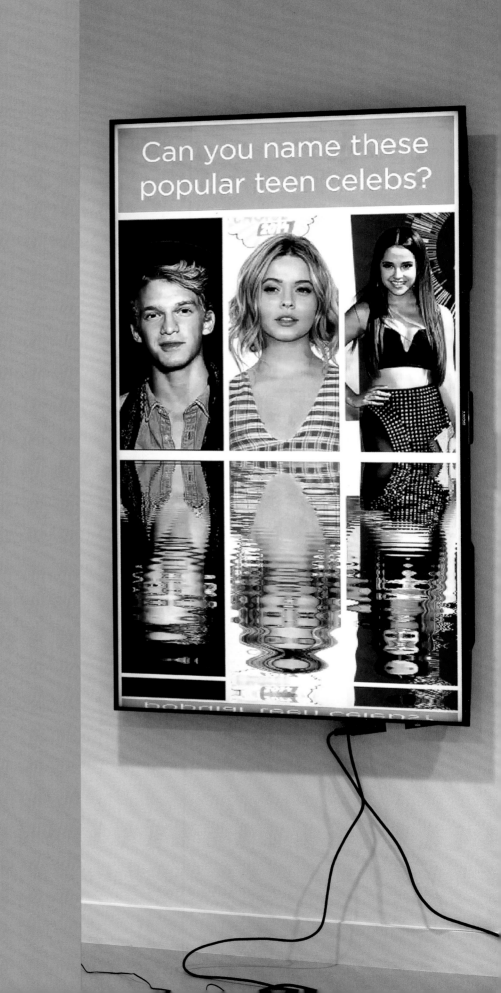

Anouk Kruithof
Sweaty Sculpture (back)
(2015)

148

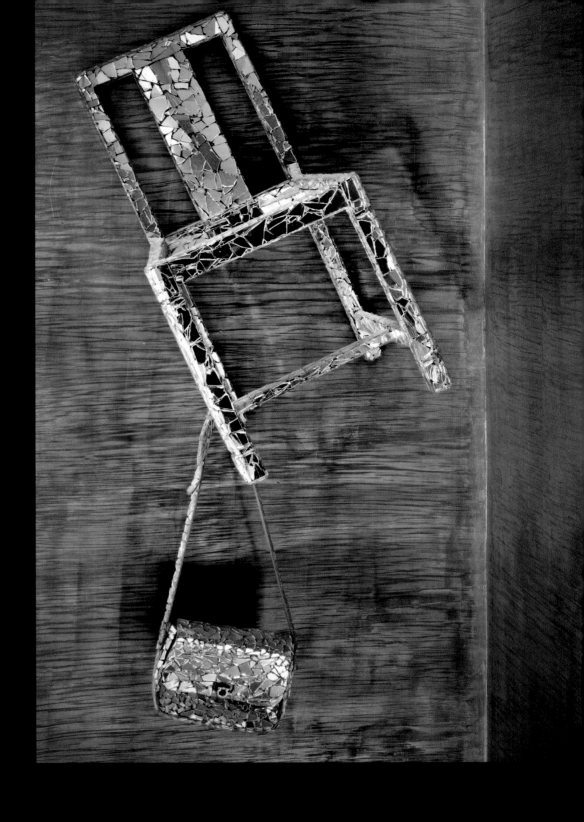

Jim Lambie
Danceteria VIII
(2006)

Paulo Nimer Pjota
Power is Timeless
(2016)

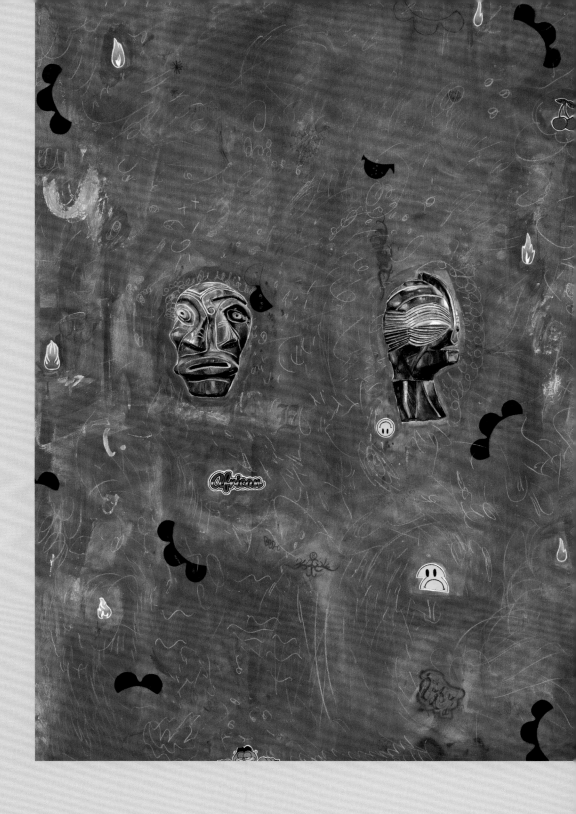

Paulo Nimer Pjota
:S
(2017)

Inez de Brauw
Migration of Order - Blue Interior
(2017)

Gaëlle Choisne
War of Images I, Distortions and Temporal Ellipse
(2017)

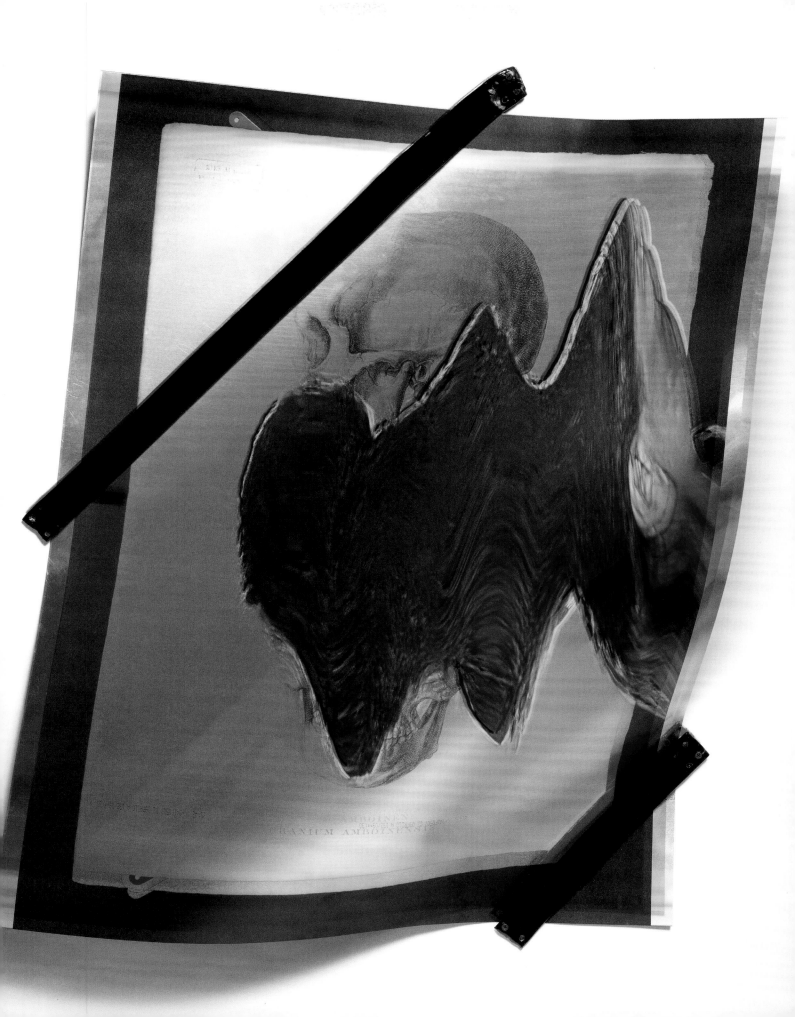

David Jablonowski
Hardcopy [Tribal Spirit]
(2016)

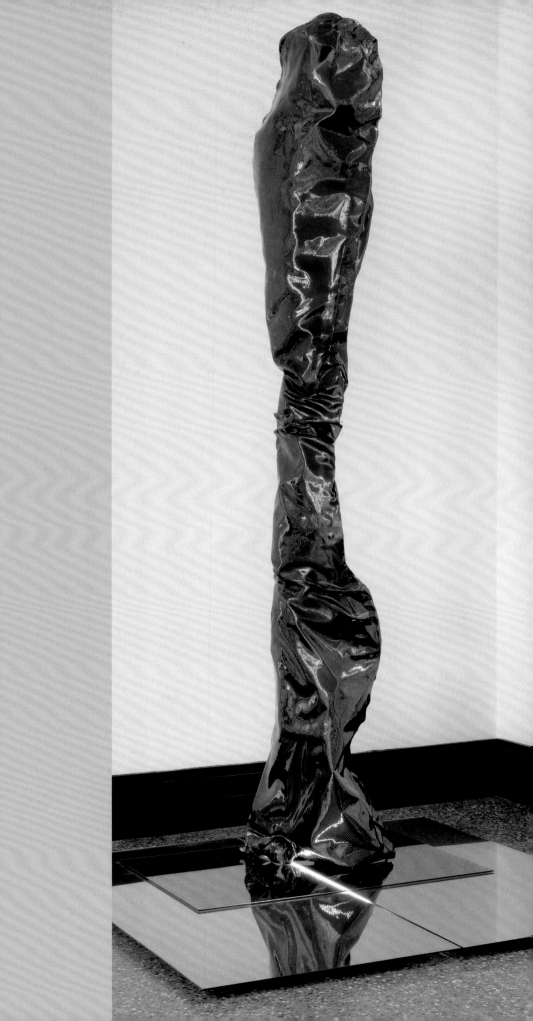

David Maljkovic
Vignettes
(2016)

Helen Johnson
Watching a Romcom after Yoga
(2015)

Bob Eikelboom
Untitled (Magnet Work series No. 6)
(2013)

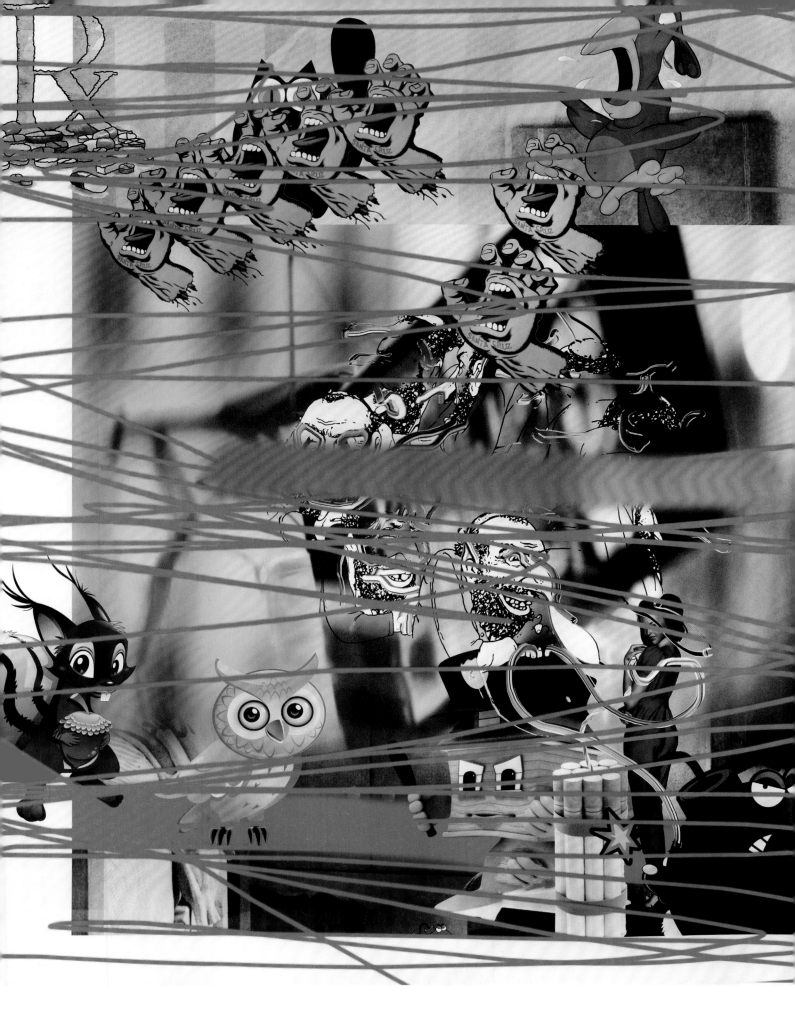

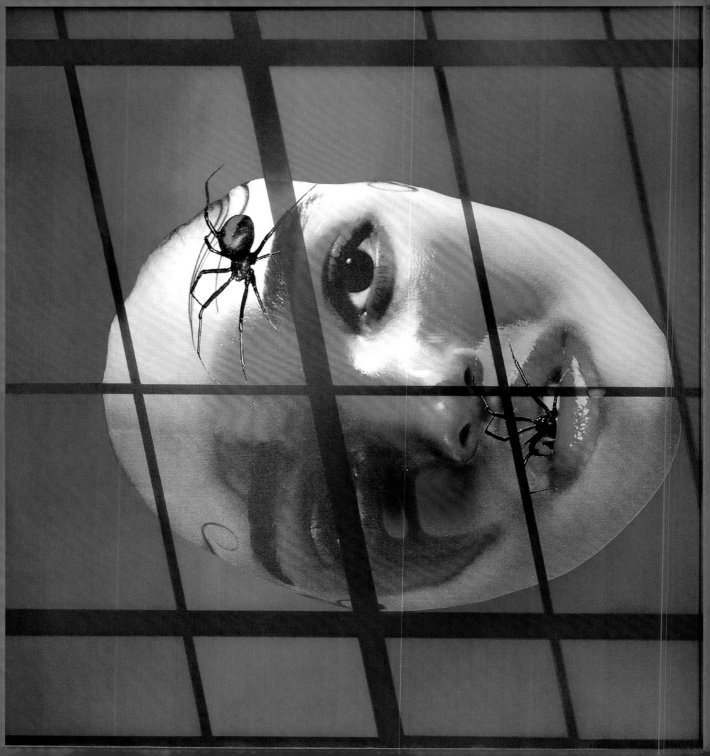

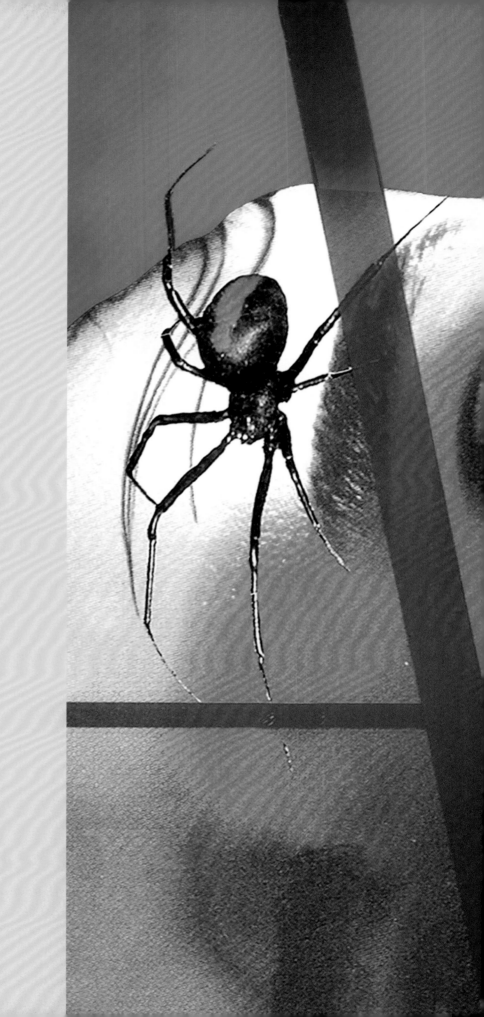

Alex Da Corte
Blue Moon Ooze
(2015)

180

Josh Smith
Untitled
(2016)

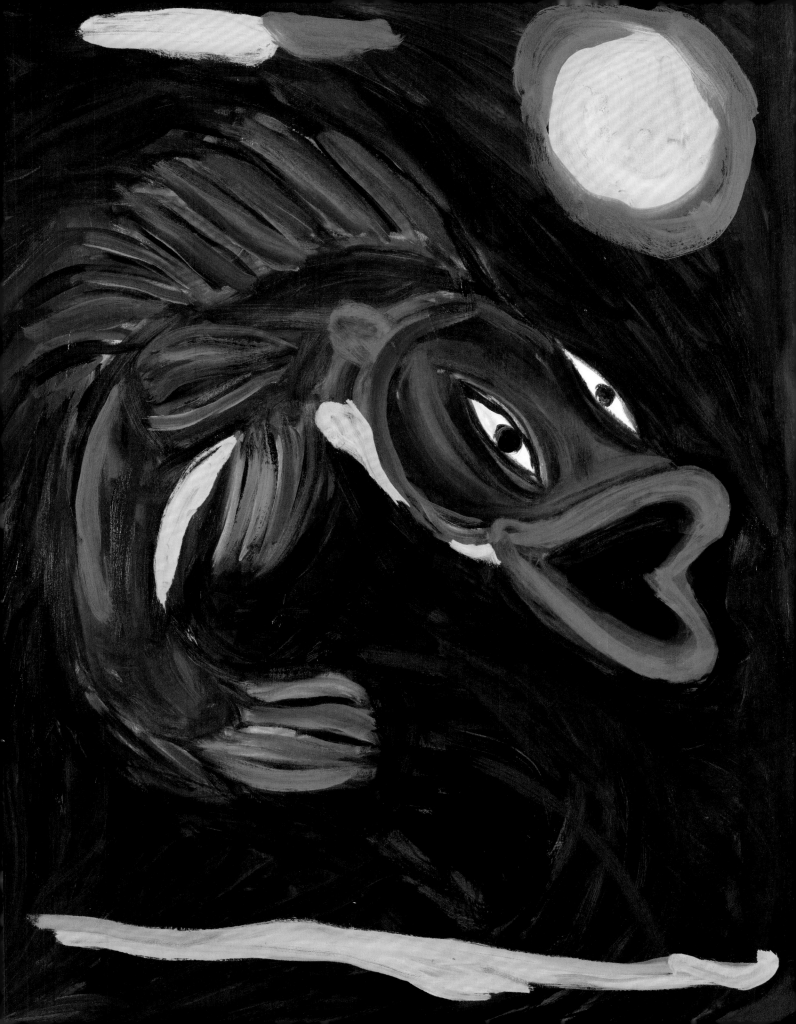

an Cheng
Entropy Wrangler (v.5)
2013)

184

Soul
Searching

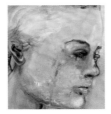

Marlene Dumas
Sad Romy (2008)
Oil on canvas
Courtesy Zeno X Gallery,
Antwerp
Photo by: Peter Cox

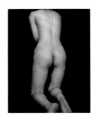

Naoto Kawahara
"Back" (2010)
Oil on canvas
Courtesy Zeno X Gallery,
Antwerp
Photo by: Peter Cox

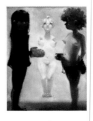

Lisa Yuskavage
Three Girls YUSLIO175
(1996)
Oil on canvas
Courtesy the artist and
David Zwirner
Photo by: Gert Jan van Rooij

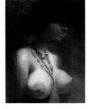

Lisa Yuskavage
Ethnic Nude YUSLIO174
(2000)
Oil on canvas
Courtesy the artist
and David Zwirner
Photo by: Gert Jan van Rooij

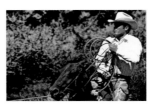

Richard Prince
*Cowboys And Girlfriends
(detail 3)* (1992)
Ektacolor photograph
Photo by: Gert Jan van Rooij

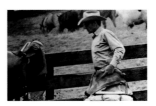

Richard Prince
*Cowboys And Girlfriends
(detail 1)* (1992)
Ektacolor photograph
Photo by: Gert Jan van Rooij

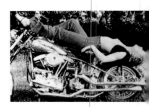

Richard Prince
Girlfriends #6 (1992)
Ektacolor photograph
Photo by: Gert Jan van Rooij

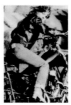

Richard Prince
Girlfriends #2 (1992)
Ektacolor photograph
Photo by: Gert Jan van Rooij

Richard Prince
Girlfriends #8 (1992)
Ektacolor photograph
Photo by: Gert Jan van Rooij

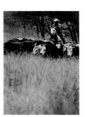

Richard Prince
*Cowboys And Girlfriends
(detail 2)* (1992)
Ektacolor photograph
Photo by: Gert Jan van Rooij

Johannes Kahrs
Figure Turning (2006)
Oil on canvas
Courtesy Zeno X Gallery,
Antwerp
Photo by: Glossner
Fotodesign, Berlin

Mircea Suciu
*"Me and the Devil" (color
palette series 2)* (2017)
Mixed media on linen
Courtesy Zeno X Gallery,
Antwerp
Photo by: Lieven Herreman

Michaël Borremans
Sweet Disposition (2003)
Oil on canvas
Courtesy Zeno X Gallery,
Antwerp
Photo by: Gert Jan van Rooij

George Condo
Untitled (2000)
Oil on clayboard
Photo by: Gert Jan van Rooij

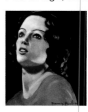

Francis Picabia
Tête de Femme (1941)
Oil on panel
Photo by: Gert Jan van Rooij

Gavin Turk
Large Red Fright Wig (2011)
Silkscreen on paper
Photo by: Gert Jan van Rooij

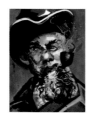

Rainer Fetting
Klabauter (2015)
Acrylic on canvas
Courtesy the artist and
Albertz Benda
Photo by: Gert Jan van Rooij

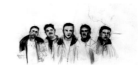

Erik van Lieshout
Five Boys - No Names (2003)
Conté on paper
Photo by: Gert Jan van Rooij

Matthew Monahan
The Sky is Fallen (2005)
Mixed Media
Photo by: Gert Jan van Rooij

 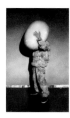 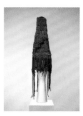 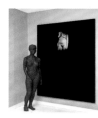

Edward Lipski
Chinese Gods (2007)
Ceramic sculpture
Photo by: Gert Jan van Rooij

Mircea Suciu
"Nostalgia"(3) (2014)
Mixed media on linen
Courtesy Zeno X Gallery,
Antwerp
Photo by: Peter Cox

Meschac Gaba
*World Trade Center
(225 Liberty street New
York, USA)* (2004)
Mixed media
Photo by: Gert Jan van Rooij

Barnaby Hosking
Untitled (2004)
Video projection and
sculpture
Photo by: Gert Jan van Rooij

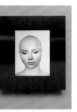 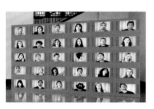

Kirstin Geisler
Touch me (1999)
Touch screen
Photo by: Gert Jan van Rooij

Candice Breitz
*Queen (A Portrait of
Madonna)* (2005)
Shot at Jungle Sound
Studio, Milan, Italy
30-channel Installation,
duration: 73 minutes, 30 sec
Gert Jan van Rooij/stills:
Photo by: Alex Fahl

Delicious
Confusion

Thomas Hirschhorn
*Clous-Mannequins
(Colonne)* (2006)
Nailed mannequins
and mixed media
Photo by: Gert Jan van Rooij

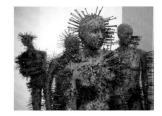

Thomas Hirschhorn
*Monazol (From the series
Des Antifongiques)* (2005)
Work on paper
Photo by: Gert Jan van Rooij

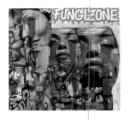

Thomas Hirschhorn
*Fungizone (From the series
Des Antifongiques)* (2005)
Work on paper
Photo by: Gert Jan van Roo

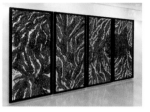

Bharti Kher
Of Bloodlines and Bastards
(2007)
Bindis on aluminium
Photo by: Gert Jan van Rooij

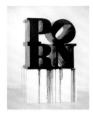

Marc Bijl
Porn (2006)
Car paint on wood
Photo by: Gert Jan van Rooij

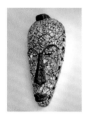

Subodh Gupta
Black Skin White Mask
(2011)
Mixed media
Photo by: Gert Jan van Rooij

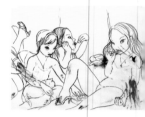

Rita Ackermann
Cold Turkey with Bonbons
(1993)
Ink and lipstick on paper
Photo by: Gert Jan van Roo

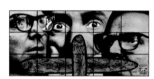

Gilbert and George
Shit on Us (1997)
Mixed media
Photo by: Gert Jan van Rooij

Raymond Barion
Carpet (Egypt) (1987)
Acrylic on canvas
Photo by: Gert Jan van Rooij

Marcel van Eeden
*Der Archeologe, die Reise
des Oswald Sollmann*
(2007-2008)
Pencil on paper
Photo by: Marcel van Eeden

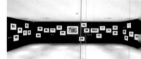

Marcel van Eeden
*Der Archeologe, die Reise
des Oswald Sollmann*
(2007-2008)
Pencil on paper
Photo by: Tom Haartsen,
Gert Jan van Rooij

Marcel van Eeden
*Der Archeologe, die Reise
des Oswald Sollmann*
(2007-2008)
Pencil on paper
Photo by: Marcel van Eeden

Jacqueline de Jong
La Garantie Pousse (1996)
Acrylic on paper
Photo by: Gert Jan van Rooij

Rita Ackermann
The Wild Hunt (2003)
Oil on linen
Photo by: Tom Haartsen

Grayson Perry
The Walthamstow Tapestry
(2009)
Fabric
Photo by: Gert Jan van Roo

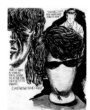

Raymond Pettibon
*No Title ("Sebring" cut?
And...)* (2013)
Ink and gouache on paper
Courtesy the artist and
David Zwirner
Photo by: Gert Jan van Rooij

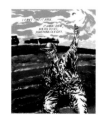

Raymond Pettibon
No Title (I can't take...) (2010)
Ink and gouache on paper
Courtesy the artist and
David Zwirner
Photo by: Gert Jan van Rooij

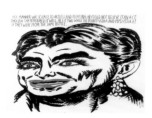

Raymond Pettibon
No Title (Her manner was...)
(2013)
Ink and acrylic on paper
Courtesy the artist and
David Zwirner
Photo by: Gert Jan van Rooij

Raymond Pettibon
No Title (Space is odorless..
(2010)
Ink and gouache on paper
Courtesy the artist and
David Zwirner
Photo by: Gert Jan van Roo

Raymond Pettibon
No Title (The opposite wall...) (2010)
Ink and gouache on paper
Courtesy the artist and
David Zwirner
Photo by: Gert Jan van Rooij

Jitish Kallat
Universal Recipient (2008)
Acrylic on canvas
Photo by: Gert Jan van Rooij

Jitish Kallat
Dawn Chorus (2007)
Acrylic on canvas
Photo by: Gert Jan van Rooij

Hernan Bas
Two Cowards at the Monument to Courage (2010)
Acrylic on linen
Photo by: Gert Jan van Rooij

Muntean/Rosenblum
Untitled ('Wherever they looked...') (2016)
Oil and chalk on canvas
Courtesy Muntean/
Courtesy the artist and
Galerie Ron Mandos,
Amsterdam
Photo by: Galerie Ron
Mandos, Amsterdam

Jen Liu
The Brethren of the Stone: Vista ex Machina (2007)
Watercolor and ink
on paper
Photo by: Gert Jan van Rooij

Gilbert and George
Dalston (2013)
Mixed media
Photo by: Gert Jan van Rooij

Kimberly Clark
Give me Change (2006)
Mixed Media
Photo by: Gert Jan van Rooij

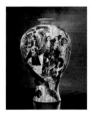

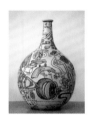

William Crawford
Untitled (1990-2000)
Pencil on paper
Photo by: Gert Jan van Rooij

Raqib Shaw
The Garden of Earthly Delight IV (2004)
Mixed media on board
Photo by: Gert Jan van Rooij

Grayson Perry
An Illusion of Depth (2003)
Glazed ceramic
Photo by: Gert Jan van Rooij

Grayson Perry
Assembling a motorcycle from memory (2004)
Glazed ceramic
Photo by: Gert Jan van Rooij

Erik van Lieshout
Kinderen (2006)
Acrylic on paper
Photo by: Gert Jan van Rooij

Win McCarthy
Untitled (Dummy) (2018)
Mixed media
Photo by: Gert Jan van Rooij

David Haines
Dissolving Prophesies (2007)
Pencil and chewing gum
on paper
Photo by: Gert Jan van Rooij

David Haines
Meatboy and Bob Starr (2016)
Pencil on paper
Photo by: Gert Jan van Rooij

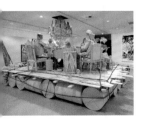

Folkert de Jong
Medusa's First Move: the Council (2005)
Styrofoam, mixed media
Photo by: Gert Jan van Rooij

Forever Young

Florian & Michael
Quistrebert
Collage II (2017)
Mixed media and blacklight
Photo by: Gert Jan van Rooij

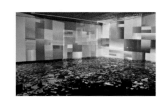

Rafaël Rozendaal
Random Fear (with Mirrors)
(2019)
Installation of mixed media
Photo by: Rafaël Rozendaal

Rafaël Rozendaal
Random Fear (with Mirrors)
(2019) (detail)
Installation of mixed media
Photo by: Rafaël Rozendaal

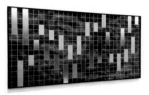

Frank Ammerlaan
Untitled (2018)
Mixed media on linen
Photo by: Gert Jan van Rooij

Florian & Michael
Quistrebert
Gold 1 (2015)
Mixed media on panel
Photo by: Gert Jan van Rooij

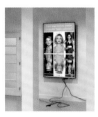

Cory Arcangel
Celebs / Lakes (2015)
Single-channel video
Photo by: Gert Jan van Rooij

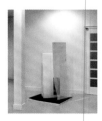

Anouk Kruithof
Sweaty Sculpture (back) (20
Mixed media and print on
plexiglas
Photo by: Gert Jan van Roo

Jack Whitten
*"SAMO Was Here
(A Dedication to the
Memory of J.M.Basquiat,
1988)"* (1988)
Acrylic on canvas
Courtesy Zeno X Gallery,
Antwerp
Photo by: John Berens

Roger Hiorns
Untitled (2010)
Pewter, foam, compressor
Copyright the Artist;
Courtesy Annet Gelink
Gallery, Amsterdam
Photo by: Gert Jan van Rooij

Nina Beier
*Slow Foxtail Separation
Rock Pattern* (2014)
Mixed media
Photo by: Gert Jan van Rooij

Jim Lambie
Danceteria VIII (2006)
Sculpture of mixed media
Photo by: Gert Jan van Roo

Paulo Nimer Pjota
Power is Timeless (2016)
Mixed media on canvas
Photo by: Gert Jan van Rooij

Paulo Nimer Pjota
:S (2017)
Mixed media on canvas
Photo by: Gert Jan van Rooij

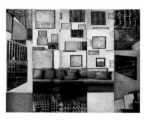

Inez de Brauw
*Migration of Order -
Blue Interior* (2017)
Mixed media on panels
Photo by: Gert Jan van Rooij

Gaëlle Choisne
*War of images I, distortion
and temporal ellipse* (2017
Ceramic enamel
Photo by: Gert Jan van Roo

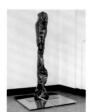

David Jablonowski
Hardcopy [Tribal Spirit]
(2016)
Carbon fibre, glass, LED
Photo by: Gert Jan van Rooij

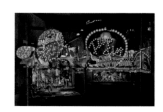

Funda Gül Özcan
FUNFAIRAFFAIR (2017)
Installation of mixed media
Photo by: Gert Jan van Rooij

David Maljkovic
Vignettes (2016)
Inkjet print on canvas
Photo by: Gert Jan van Rooij

Helen Johnson
*Watching a Romcom after
Yoga* (2015)
Polymeer paint on
canvas
Photo by: Gert Jan van Roo

ob Eikelboom
*Untitled (Magnet Work
Series No. 6)* (2013)
namel paint and magnets
n steel
hoto by: Gert Jan van Rooij

Jordan Wolfson
Untitled (2012)
Inkjet print on paper
Courtesy the artist, David
Zwirner and Sadie Coles
HQ, London
Photo by: Gert Jan van Rooij

Alex Da Corte
Blue Moon Ooze (2015)
Spray paint on paper
Photo by: Gert Jan van Rooij

Josh Smith
Untitled (2016)
Oil on canvas
Courtesy the artist &
Xavier Hufkens,
Brussels
Photo by: Farzad Owrang

n Cheng
ntropy Wrangler (v.5)
2013)
ideo
hoto by: Ian Cheng

Jack Whitten
"Escalation IV" (2015)
Acrylic on canvas
Courtesy Zeno X Gallery,
Antwerp
Photo by: Peter Cox

Colophon

This book was published on the occasion of the exhibition *Trouble in Paradise. Collection Rattan Chadha* at the Kunsthal in Rotterdam from 7 February to 26 May 2019.

AUTHORS

Emily Ansenk: director Kunsthal Rotterdam
Sacha Bronwasser: writer
Jhim Lamoree: publicist
Liesbeth Willems: art curator KRC Collection

TRANSLATION

Christine Gardner

EDITED BY

Charlotte Martens, Liesbeth Willems

DESIGN

ARK Amsterdam (Roosje Klap & Pauline Le Pape,
with many thanks to Guillaume Roux & Katharine Wimett)

TYPEFACES

RC1&2 by Pauline Le Pape, *Atlas Grotesk* by Carvalho/Bernau

LITHOGRAPHY

BFC, Bert F. C. van der Horst, Amersfoort

PHOTOGRAPHY

John Berens, Peter Cox, Alex Fahl, Glossner Fotodesign, Tom Haartsen, Lieven Herreman, Farzad Owrang, Gert Jan van Rooij

PRINTING

Wilco Art Books, Amersfoort

PAPER

Colorplan Bright Red (endpapers) en Luxo Art Samt (inside papers)

PUBLISHER

Eelco van Welie, nai010 publishers, Rotterdam

PRODUCTION

Milou van Lieshout, nai010 publishers, Rotterdam

THANKS TO

Rattan Chadha, Floor Haverkamp, KRC Collection; Mariette Maaskant, Eva van Diggelen, Kunsthal Rotterdam; Jhim Lamoree and Sacha Bronwasser

ARTISTS

Rita Ackermann (1968), Frank Ammerlaan (1979), Cory Arcangel (1978), Raymond Barion (1946), Hernan Bas (1978), Nina Beier (1975), Marc Bijl (1973), Michaël Borremans (1963), Inez de Brauw (1989), Candice Breitz (1972), Ian Cheng (1984), Gaëlle Choisne (1985), George Condo (1957), William Crawford (Unknown), Alex Da Corte (1980), Marlene Dumas (1953), Marcel van Eeden (1965), Bob Eikelboom (1991), Rainer Fetting (1949), Meschac Gaba (1961), Kirstin Geisler (1949), Gilbert and George (1943,1942), Subodh Gupta (1964), David Haines (1969), Roger Hiorns (1975), Thomas Hirschhorn (1957), Barnaby Hosking (1976), David Jablonowski (1982), Helen Johnson (1979), Folkert de Jong (1972), Jacqueline de Jong (1939), Johannes Kahrs (1965), Jitish Kallat (1974), Naoto Kawahara (1971), Bharti Kher (1969), Kimberly Clark (1975, 1977, 1969), Anouk Kruithof (1981), Jim Lambie (1964), Erik van Lieshout (1968), Edward Lipski (1966), Jen Liu (1967), David Maljkovic (1973), Win McCarthy (1986), Matthew Monahan (1974), Muntean/Rosenb[...] (1962), Paulo Nimer Pjota (1988), Funda Gül Özcan (1984), Grayson Perry (1960), Raymond Pettibon (1957), Francis Picabia (1[...] 1953), Richard Prince (1949), Florian and Michael Quistrebert (198[...] 1976), Rafaël Rozendaal (1980), Raqib Shaw (1974), Josh Smith (19[...] Mircea Suciu (1978), Gavin Turk (1976), Jack Whitten (1939-2018), Jordan Wolfson (1980), Lisa Yuskavage (1962)

nai010 publishers is an internationally orientated publisher specia[...] in developing, producing and distributing books in the fields of architecture, urbanism, art and design.
www.nai010.com

nai010 books are available internationally at selected bookstores a[...] from the following distribution partners: North, Central and South America - Artbook | D.A.P., New York, USA, dap@dapinc.com
Rest of the world - Idea Books, Amsterdam, the Netherlands, idea@ideabooks.nl
For general questions, please contact nai010 publishers directly at sales@nai010.com or visit our website www.nai010.com for further information.

The Kunsthal Rotterdam is situated in the cultural hub of Rotterda[...] and is one of the leading art institutions of the Netherlands. The Kunsthal was designed in 1992 by the renowned Dutch architect Rem Koolhaas and is one of the icons of modern architecture. The Kunsthal has seven exhibition spaces, a lively café and an Auditori[...] where it presents a dynamic programme of more than 23 exhibitio[...] a year, together with many activities and events. By constantly offering several exhibitions simultaneously, the Kunsthal is able to offer an adventurous journey through a variety of cultures and artistic movements: from historical and classical art to modern an[...] contemporary art, design, fashion and photography. Varying from[...] art and popular culture, multidisciplinary and always accessible fo[...] broad public.
www.kunsthal.nl

Printed and bound in the Netherlands

ISBN 978-94-6208-4919
NUR 644
BISAC ART006000